RIPON
THROUGH TIME
Maurice Taylor
& Alan Stride

AMBERLEY PUBLISHING

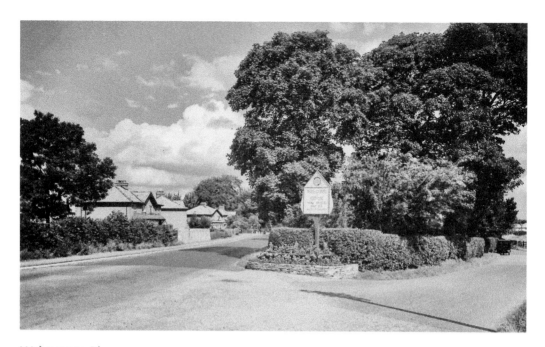

Welcome to Ripon

First published 2011

Amberley Publishing
The Hill, Stroud,
Gloucestershire, GL5 4ER

www.amberley-books.com

Copyright © Maurice Taylor & Alan Stride, 2011

The right of Maurice Taylor & Alan Stride to be
identified as the Authors of this work has been
asserted in accordance with the Copyrights, Designs
and Patents Act 1988.

ISBN 978 1 4456 0003 1

British Library Cataloguing in Publication Data.
A catalogue record for this book is available from
the British Library.

Typeset in 9.5pt on 12pt Celeste.
Typesetting by Amberley Publishing.
Printed in the UK.

Introduction

Ripon is situated on the western edge of the Vale of York, at the foot of Wensleydale, close to the confluence of the rivers Ure and Skell. Some 250 million years ago, it was on the edge of the shallow Zechstein sea. Conditions were similar to the Arabian Gulf. Rock formations from this time can be seen at Quarry Moor.

Indicated, partly, by burials on Ailcey Hill, Anglo-Saxons had settled between the two rivers possibly as early as the sixth century. During the 650s, the King of Northumbria had founded a monastery of Celtic monks with the famous St Cuthbert as guest-master.

Ownership passed to St Wilfrid in 660, who, besides being abbot of both Ripon and Hexham, served at times as Bishop of Northumbria, Bishop of York, and Bishop of Hexham. He accumulated great wealth and under his influence Ripon monastery became known throughout Europe, and his name has been honoured in the city ever since.

After the destruction by the Danes, and the Harrying of the North by the Normans, in the second half of the twelfth century, Roger, Archbishop of York, built a new minster at Ripon. He laid out a new market place and town centre. The same basic street plan survives today.

Ripon's economy developed with cattle and sheep fairs and cloth making, and during the fifteenth century, Ripon, with Boroughbridge, became a leading cloth producer. St Wilfrid's shrine put Ripon on the pilgrim trail, although at times this source of revenue was affected by plague and building repairs.

In the early twelfth century, three hospital chapels had been established in Ripon: St John's, St Mary Magdalen's (the leper chapel) and St Anne's. St Mary Magdalen's still survives as a Grade I-listed building.

The minster, with its special sanctuary status, offered lifetime refuge to those fleeing the King's justice. Later, the cloth industry moved to the industrial West Riding, and at the Reformation the minster lost its revenues and canons. Catholic sympathy was strong in the area,

and an estimated 300 rebels were executed in Ripon following the unsuccessful 1569 Rising of the North.

In 1604, King James granted a new charter to the minster, restoring part of its endowments and establishing a Dean and a Chapter. In the same year, he granted a charter to the town reorganising its government and creating the office of Mayor.

Under the Archbishops of York, a 'Wakeman' had organised the parish officers, e.g. neatherd, pinder, swineherd, hornblower, to set the watch (curfew) and constables to patrol the streets. The 'setting of the watch' is still performed each evening at 9 p.m. in the Market Square. In 1617, James I passed through Ripon and was presented with a set of silver spurs from this flourishing trade.

By the eighteenth century, John Aislabie of nearby Studley Royal, generously supported the cost of the new obelisk, which his son, William, subsequently restored. Local communications improved: the main approach roads were turnpiked, a canal was built, and regular stage-coach services were provided to Newcastle, Leeds and London. Horse and cattle fairs attracted rowdy gatherings, but polite society enjoyed a new racecourse, theatre and Assembly Rooms.

In 1836, the minster church became the cathedral for the newly established diocese of Ripon, the first after the Reformation, and the old town became a city. A Bishop's Palace was built.

A railway, new hospital, new workhouse, training college for women teachers, new grammar school buildings and several primary schools all followed. New churches and chapels mushroomed; slums were cleared.

Early in the twentieth century, the Ripon Spa was created, and with the outbreak of the First World War, an army camp was built three times the size of the city. The Second World War also brought soldiers and RAF personnel from nearby airfields.

The second half of the twentieth century saw Ripon almost double in size as it sought to encourage light industrial development. Local Government reorganisation in 1974 reduced the city council to a parish council within Harrogate Borough and brought the loss of the coveted 'city' status, fortunately reinstated when the Queen graciously granted honorary city status.

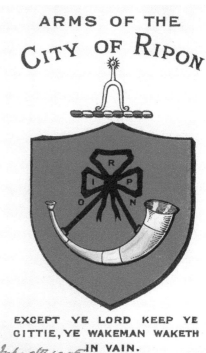

ARMS OF THE
CITY OF RIPON

EXCEPT YE LORD KEEP YE
CITTIE, YE WAKEMAN WAKETH
IN VAIN.

feb. 9th 1905

PARKER, RIPON. Copyright.

The Arms of the City of Ripon

'The Arms of the City of Ripon' are seen here on a card purchased in 1905. Stephen Tucker, Rouge Croix of the College of Heralds, had said he had 'not been able to make the banner an armorial one [as] Ripon is not and never was entitled to arms and is, I believe, the only city in England so circumstanced'. The 'Arms' include the symbols of the horn, of the mythical King Alfred charter, and the famous Ripon rowel spurs from the seventeenth/ eighteenth century.

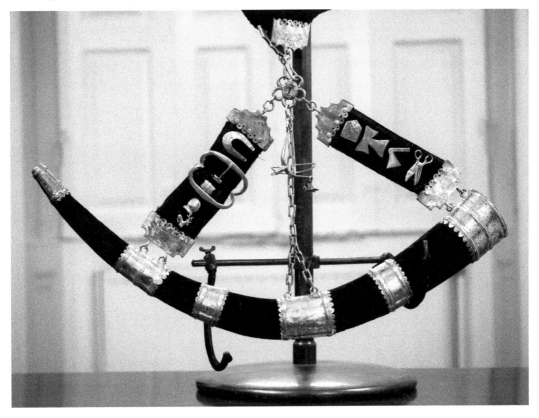

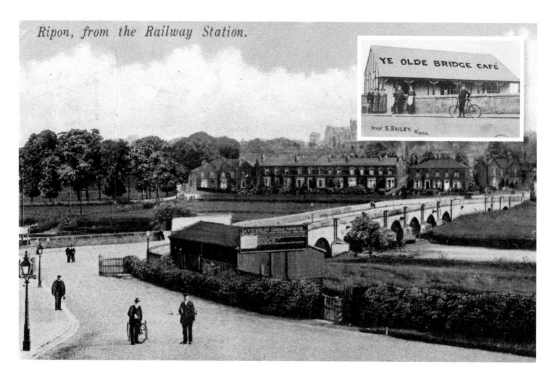

Ripon, from the Railway Station.

YE OLDE BRIDGE CAFÉ

Propⁱ S. BAILEY, Ripon.

North Bridge from Ure Bank

This view greeted visitors as they left the railway station and headed for the city centre. North Bridge crosses the unpredictable River Ure at the narrowest point on the floodplain. The variety of its arches reflects piecemeal repairs over the centuries. By the fifteenth century, it carried the Chapel of St Sitha and much later on 'Ye Old Bridge Cafe' was positioned there. Thousands of troops arrived at the railway station during the First World War.

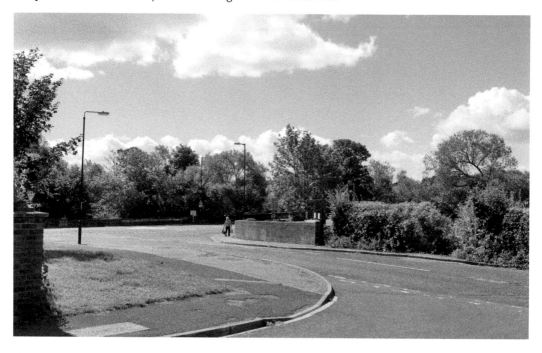

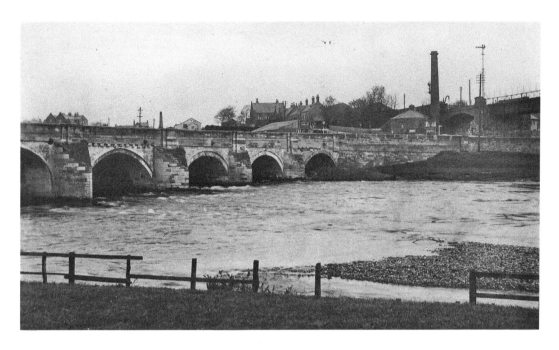

North Bridge

Settlement of the boundary dispute in 1621 meant that North Bridge belonged to the West Riding. Between 1879–81, it was doubled in width to take increased traffic brought by the railway. The Ure rises notoriously quickly and many have lost their lives in its waters. One stormy night in 1821, floods nearly claimed the 'Telegraph' coach and its passengers, while three huntsmen, two ferrymen and nine horses drowned in the Newby Ferry Disaster of 1869.

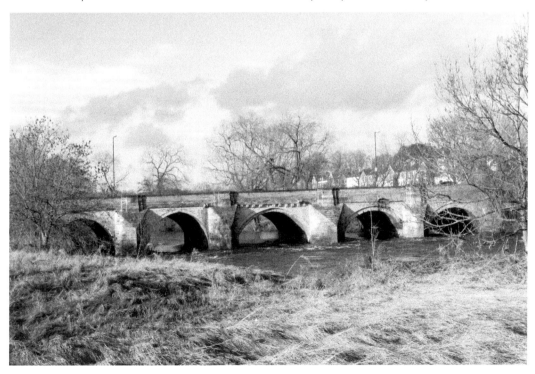

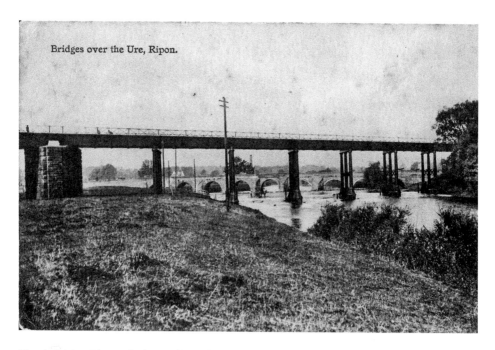

Bridges over the Ure, Ripon.

North Bridge Through the Arches of the Railway Bridge

The first pile of the railway viaduct over the River Ure, below the North Bridge, Ripon, was driven on 22 March 1857, and eighteen months later, on 14 September 1848, the line opened between Ripon and Harrogate. Under the cuts of the 1960s, the last goods train left Ripon Station for York at 8.30 a.m. on 3 October 1969. The A61 Ripon bypass follows the line of the old bridge.

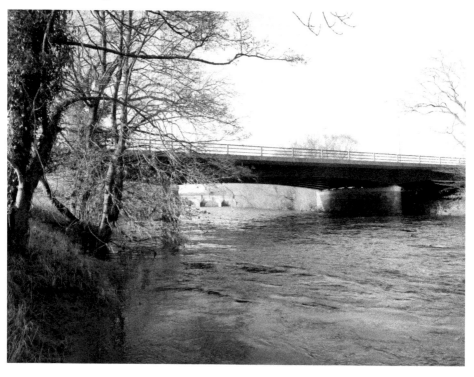

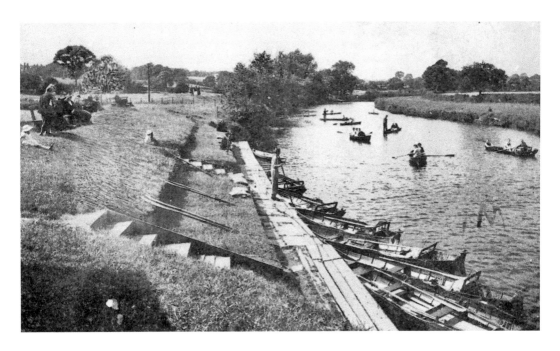

The Old Boating Stage

The Ure could quickly turn dangerous following heavy rain, but generally it offered good facilities. The boating station stood adjacent to the pumping station – later Duffield's Wood Yard and now the leisure club. Upstream, a twenty-cubicle bathing pavilion for males only was built in 1870, open five months of the year. After a swimming pool had been added to the spa baths, the pavilion was demolished in 1951.

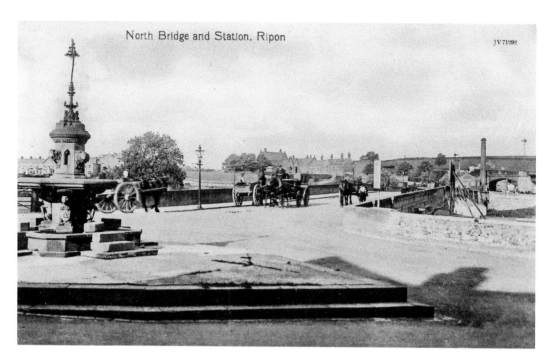

North Bridge and Station, Ripon

JV 71292

North Bridge

Standing at the junction of Magdalen's Road and North Road, at the entrance to North Bridge, is the 1875 Severs' fountain. Enclosure of the common here meant that animals being driven to market could no longer access the river to drink. Neither could the farmers. So, in 1875, Dr John Severs provided this drinking fountain with two troughs. It survived here until 1929 when it was moved to Spa Park, where it stands today but without its pinnacle.

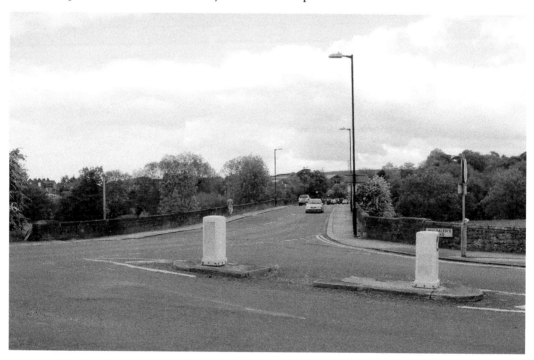

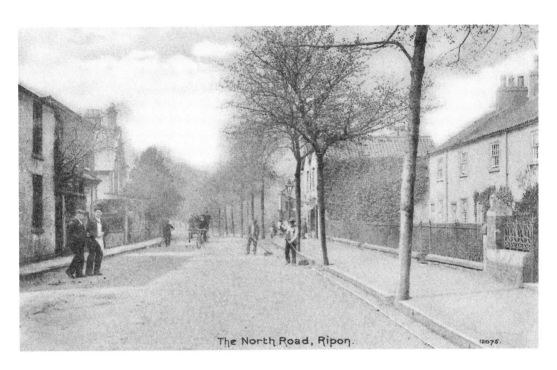

The North Road, Ripon.

12075.

North Road

Development along North Road largely followed the opening of the railway. Later, to enhance the view, the lime trees lining the road were paid for by the Marquis of Ripon. Livestock sales were held in a field behind the Station Hotel in 1893, but until at least 1912 were back on the Market Place. The Auction Mart returned to North Road, closing after the outbreak of foot and mouth disease in 2001/02.

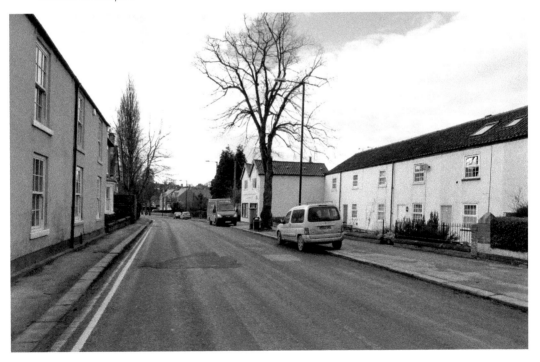

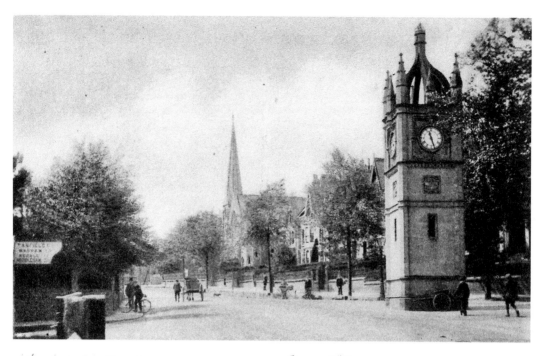

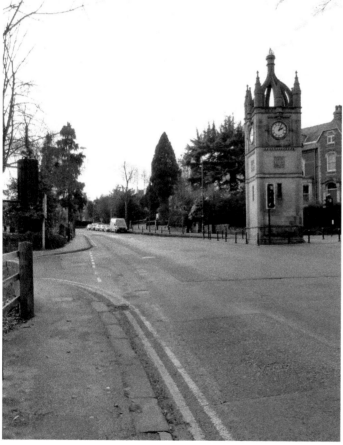

North Road and Clock Tower

The 43-foot-high Clock Tower was built for Queen Victoria's Jubilee, 1897. It was the gift of the Misses Cross and placed here to impress visitors arriving from the railway station. In the centre stands the Congregationalist church of 1870, with a school behind. The church closed in 1970, having served as the warehouse of a poultry firm. At 1 Princess Road stood Ripon Clergy College, founded in 1898, transferring to Oxford in 1919.

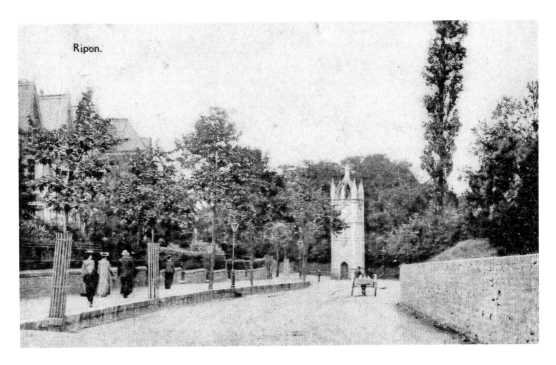

Ripon.

North Street and Clock Tower

From the middle of the nineteenth century, North Road bore increasing volumes of traffic between the railway station and the town centre. Following the construction of the bypass, traffic has been directed round the city to approach from the north to negotiate the obstacle of the Clock Tower. To the front right, off picture, stands the police station built in the 1950s on the site of the malt kilns.

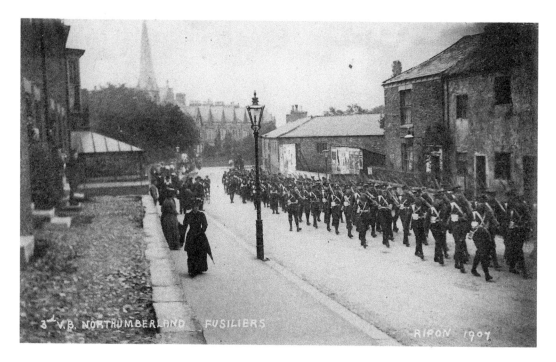

North Street

The year is 1907 and soldiers march from the railway station to camp at Hell Wath. To boost its flagging economy, Ripon was desperate to encourage military usage at this time. Opposite the Crescent stood Hepworths malt kilns. In 1903, Hepworths had a brewery and wine and spirit stores in Bondgate, offices in Middle Street and malt kilns in North Street. Hepworths sold ale, double brown stout and twelve-year-old Wakeman-brand Scotch whisky, at 49s for a dozen bottles.

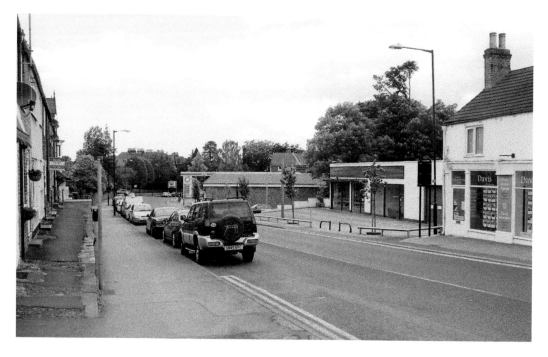

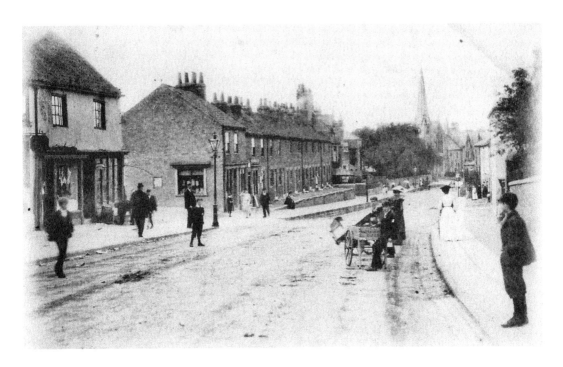

North Street

The pinfold, where stray beasts were impounded, stood in the road between the White Horse Inn and the Crescent with an auction mart from 1881 where Brewster and Christian Terrace stand. 44 North Street boasted a photographer's studio into the twentieth century. North House Surgery was the Town House, planned as the mayor's official residence. In 1903, medical officer Dr Jefferson lived there. His son was killed when his submarine was torpedoed off Fair Isle in July 1917.

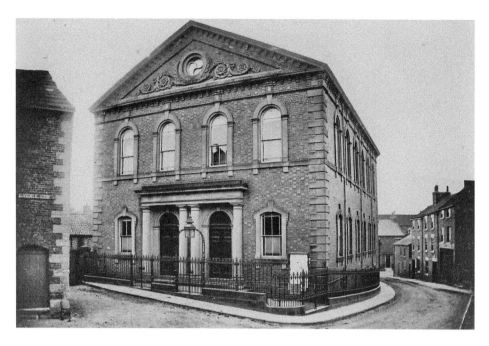

Coltsgate Hill Chapel

In 1533, this route, leading across the open country to the ford at West Tanfield, was where the colts were tethered, and it was known as Coltestakes. In 1771, it was Cowsgate Hill. The chapel, founded in 1777, was the town's first Wesleyan chapel. Rebuilt in 1861 to seat 1,000 worshippers, services continued until August 1962. For a short time, it was used by 'U-Save', but has stood empty for many years.

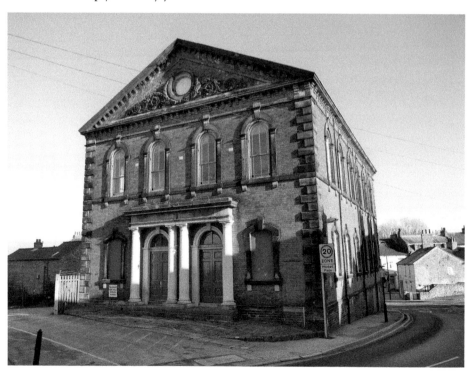

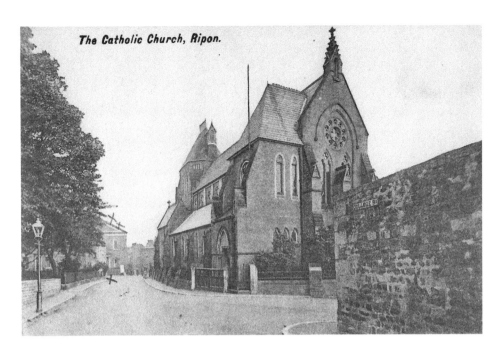

The Catholic Church, Ripon.

St Wilfrid's Catholic Church

Joseph Hansom's St Wilfrid's Catholic church of 1862 replaced a meeting room off Low Skellgate, used after Roman Catholics were permitted to worship in public following the Reformation. Until 1939, the secondary school was housed in buildings opposite the Wesleyan Chapel. 'Killikrankie', the footpath opposite the Catholic church, was named after the battles between the boys of the grammar and secondary schools. It is one of the public foot roads established after the enclosure of the commons.

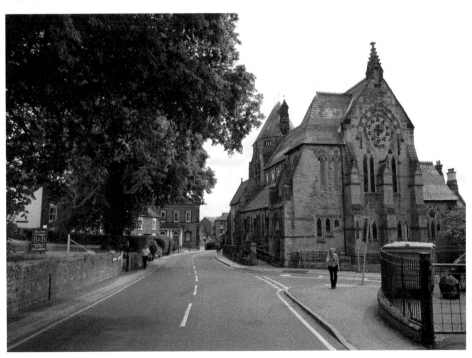

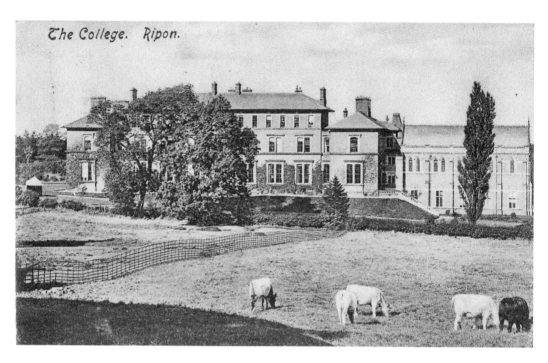

The College. Ripon.

Ripon Training College

Built in 1862 to train women teachers for Church of England elementary schools, the college is seen here after the addition of the chapel to the right in 1899. Following major expansion and reorganisation, it became a mixed college of Higher Education on two campuses, amalgamating with St John's College, York, and not exclusively concerned with teacher training. It closed in 2001, and the site was sold for housing and light industrial use.

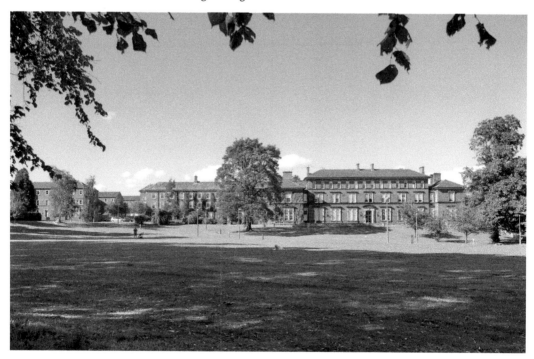

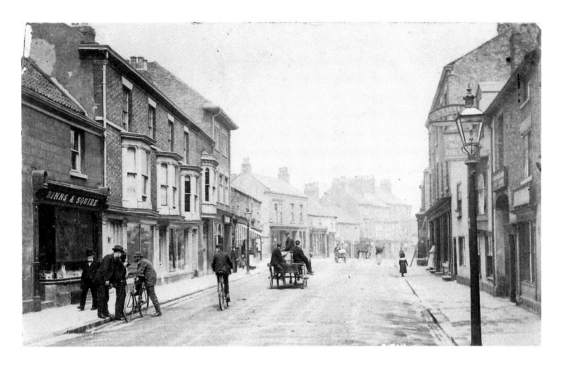

North Street

The white building on the right was the Saracen's Head, and at No. 21 stood the British Iron & Implement Works established by Henry Kearsley in 1826. The Kearsley family also owned one of the paint works. When this card was postmarked, 1904, the post office at No. 23 still had over a year to go until it opened. The bay-windowed block on the left, for nearly a century, was Abbott's furniture showrooms. Beyond that, Coltsgate Hill was redeveloped around the year 2000.

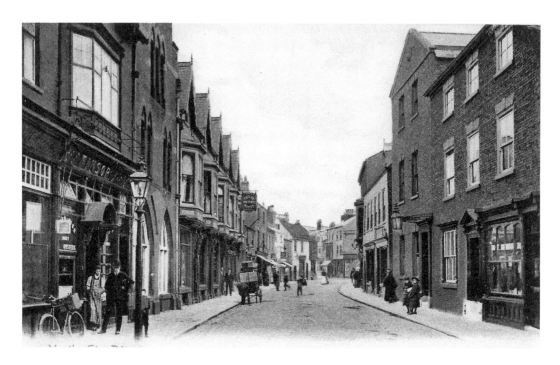

North Street

North Street was widened in the 1870s. On the left, with its owner, is Winsor's fish and game shop. Next door was Abbot's first showroom, and at No. 74 their other site currently planned for development. Smithson's butcher's, far right, still flourishes under different ownership. The solicitor's in the tall building, right, was founded in the Market Place by Samuel Wise. By 1903, the firm had moved to North Street and became Hutchinson & Buchanan in 1919.

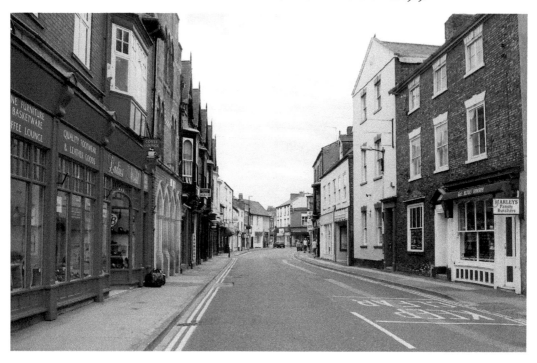

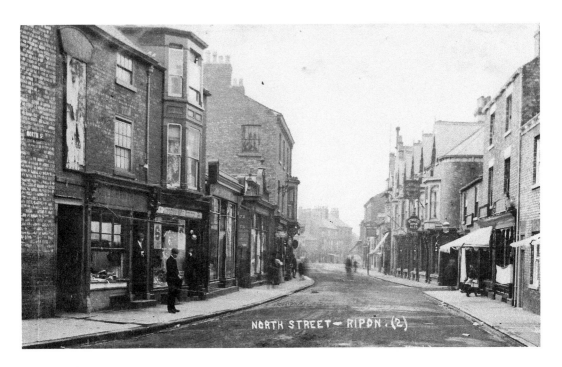

NORTH STREET — RIPON . (2)

North Street

North Street was called Horsefair up to the nineteenth century. This important early route took traffic from Allhallowgate and the Market Place via Coltsgate Hill to the fords at West Tanfield or for the Great North Road. As part of the redevelopment following the road widening, the St Wilfrid's hotel was built at the junction of Allhallowgate and North Street.

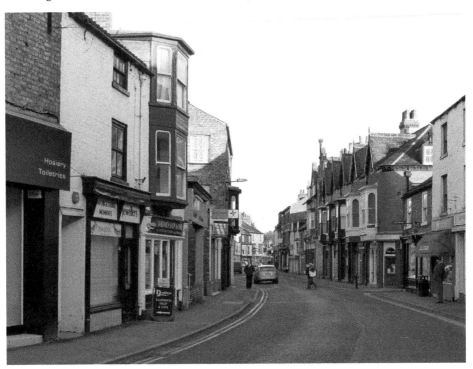

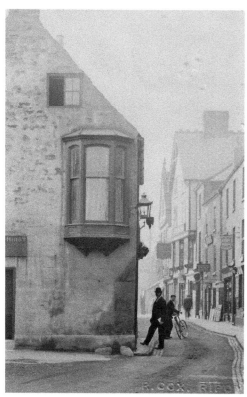

Fishergate

Leading north from the Market Place, Fishergate's narrowness was causing concern at the turn of the twentieth century. This 1906 view, looking south, shows it immediately prior to the demolition of its eastern (left) side when its width was doubled. The Grapes Inn at the corner of Lavender Alley was the last building to go. A note on the back of the card says that the man standing facing the Grapes is taking an inventory ready for the sale.

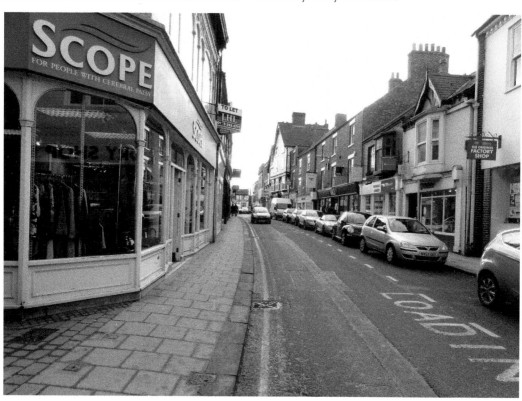

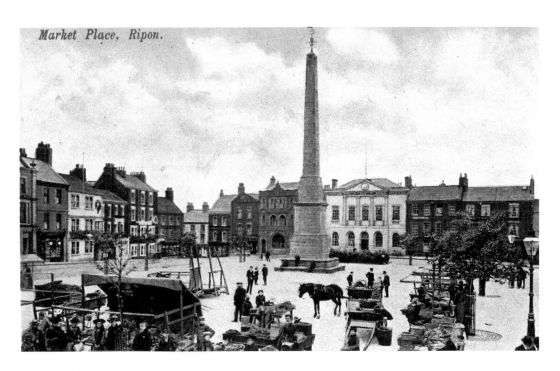

Market Place, Ripon.

Market Place

The focal point is undoubtedly the obelisk, built in 1702 by John Aislabie of Studley Royal, then Mayor of Ripon. The obelisk replaced an earlier market cross, and Aislabie bore more than half the cost, as well as providing the limestone from his quarries at Studley. Standing 90 feet high, it is topped by a rowel spur and horn, symbols of Ripon's ancient crafts and customs, and was extensively restored in 1985. This card is postmarked 1903.

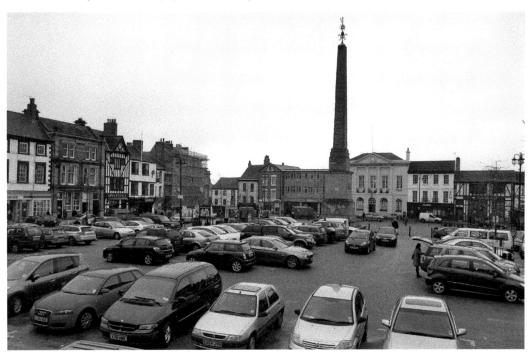

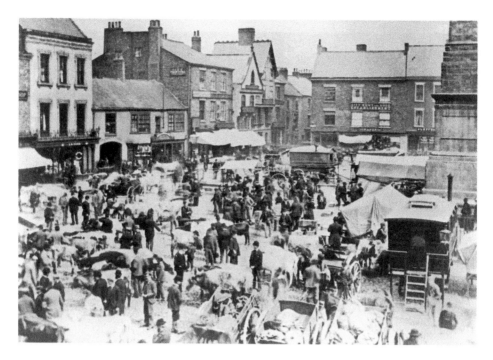

Market Place North

Since it was laid out under the orders of the Archbishop of York in the twelfth/thirteenth century, Ripon's commercial life has been focused on the Market Place, providing the archbishop with a handsome income from rents, tolls and other dues. The regular weekly market, seen here about 1904, typifies the fairs and markets held on the square for centuries. Note the unwidened entrance to Fishergate.

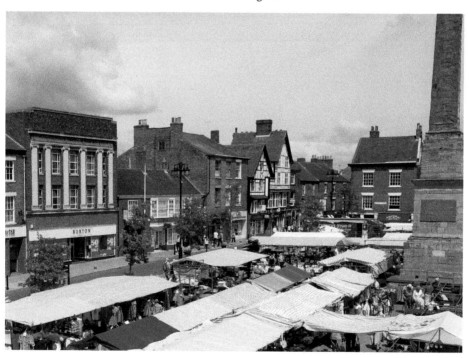

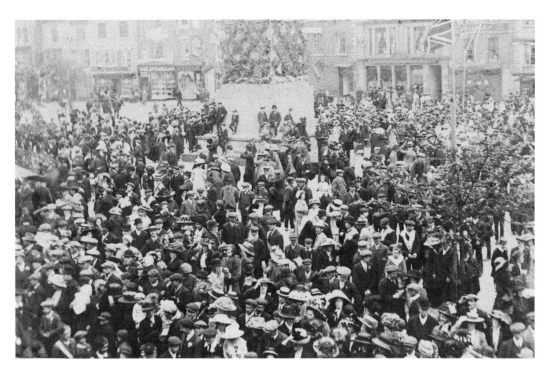

Market Place Crowds

The oldest freestanding monumental obelisk in the country, it was designed by the celebrated Nicholas Hawksmoor. In 1781, John Aislabie's son, William, had the obelisk restored to celebrate his sixty years as Ripon's MP. The plaque, added later, confusingly implies that he was the original builder. Four small obelisks stood around its base, but these were removed in 1882. Crowds gather around the obelisk (*above*) for the 1911 Coronation and (*right*) for the visit of Queen Elizabeth II.

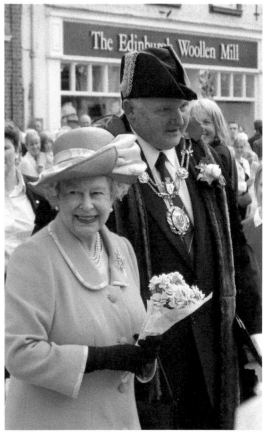

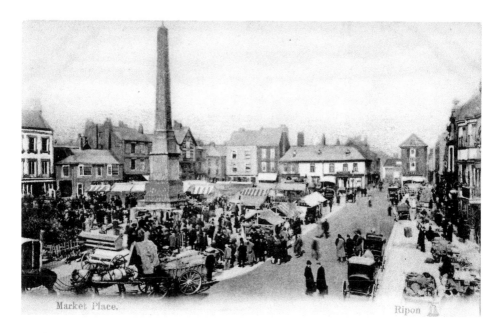

Market Place. Ripon

Market Place

The visual impact of the Market Square stems from its size and spaciousness, especially when reached down narrow streets. Until late-Victorian times, the approaches were even narrower and, in the north-east corner, Middle Street halved the width of what is now Queen Street. The widening of Queen Street in around 1905 eventually brought an end to the practice of siting some market stalls in front of the shops along the east side of the square, as seen here.

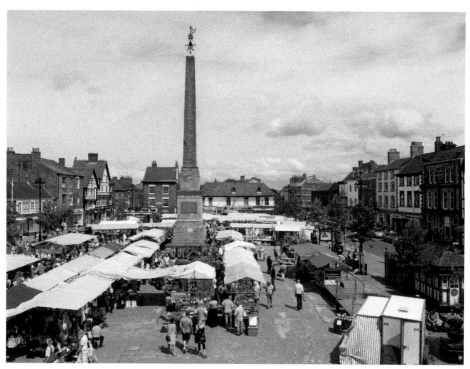

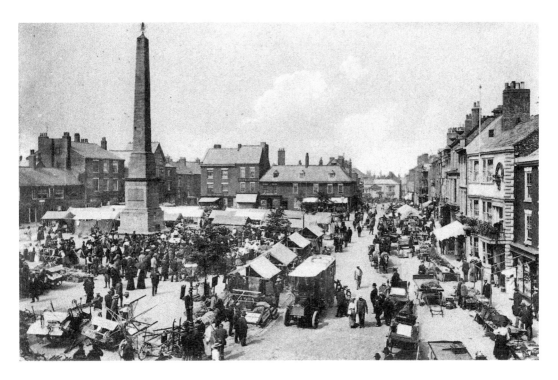

Market Day

This card is postmarked November 1909 and shows the effect of the demolition, a year or two earlier, of Middle Street to create Queen Street, and the removal of one bay of the building, now Thomas's baker's, to widen Fishergate by some 3 metres. Note there are still stalls on the east side of the market place. The omnibus in the road carried passengers between the Unicorn Hotel and the railway station at Ure Bank.

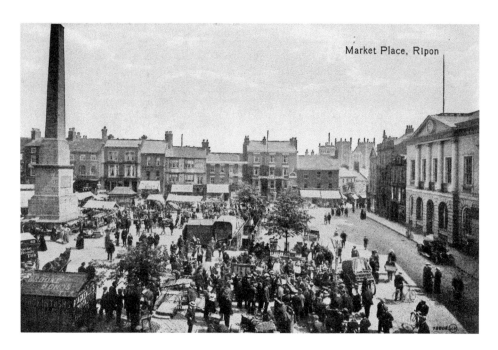

Market Place, Ripon

Market Day

A busy market around the time of the First World War with cars still rare. The Crown closed in 1907; Croft & Blackburn's Motor Works took over in 1908 and Morrisons (now Sainsbury's) in 1974. The cabmen's shelter arrived in 1911. Bateman's drapers, at No. 1 on the corner of Kirkgate, became Etheringtons, then Dixons, then the Blue Bird Café until demolished for road widening in 1931. The Skipton Building Society now occupies the site.

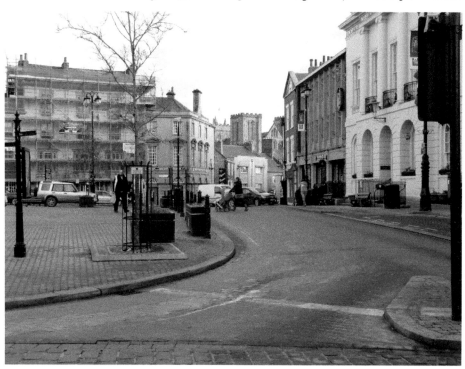

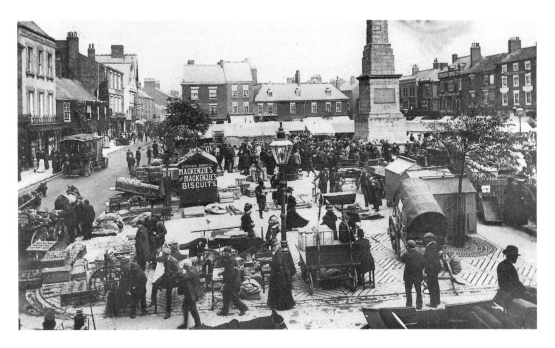

Market Place
This card, postmarked 1910, shows the layout of the market at that time, with stalls at the northern end while at the southern end local traders offer their produce in a less formal arrangement. Note the entrance to the toilets on the right.

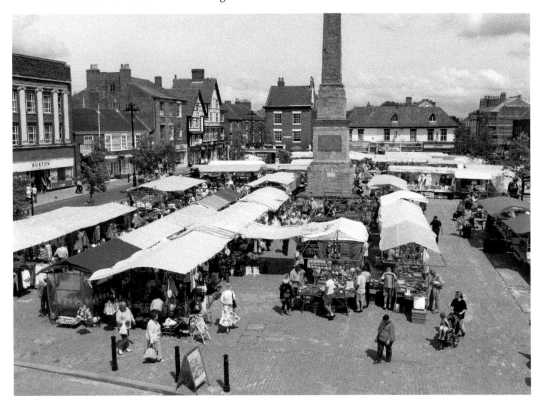

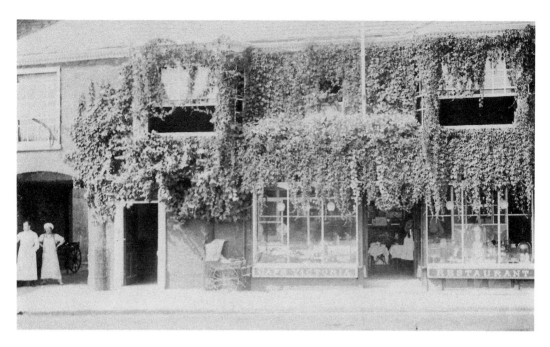

27 Market Place

Currently occupied by Boots Chemist, this property was comprised of two burgage plots amalgamated in 1672 by the Wright family. By 1792, it was the Minster Inn, later the York Minster Inn, then an ironmonger's. When sold in 1898 by the Studley Estate, James Wright had already established the Café Victoria, which survived into the 1970s, hosting meetings of the Ripon Club. Redevelopment was approved in 1975, but during construction the front became unstable and a replica was built.

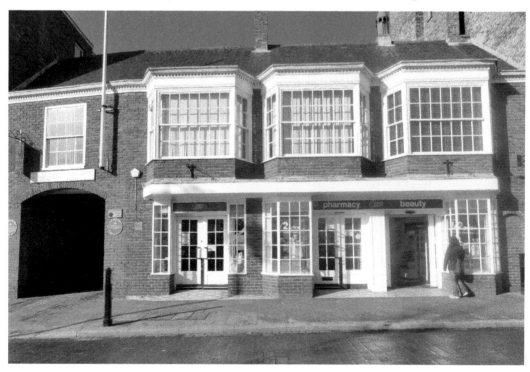

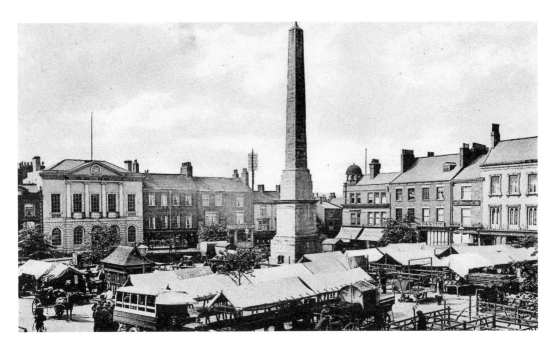

Market Day just before the First World War

Note that animal pens are back on the square. Beyond the motor bus can be seen the cabmen's shelter provided in 1911 for local horse cabdrivers by Miss Sarah Carter, daughter of a former mayor. In later years, it fell into disuse but in 1985, in view of its rarity, Ripon Civic Society undertook its restoration. The telegraph office, from 1869 at No. 35, can be picked out by the mast.

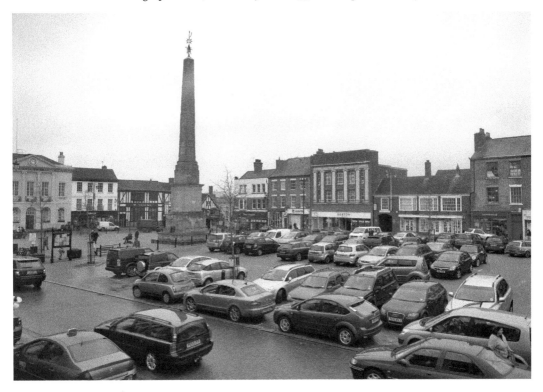

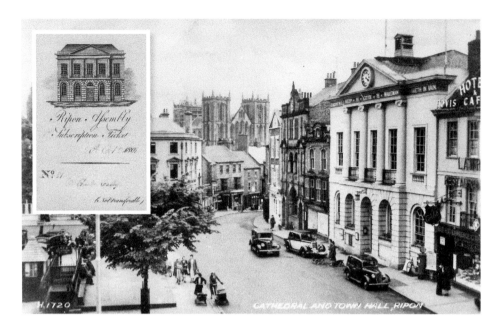

Market Place South

Designed by James Wyatt in 1801, the town hall was built for Mrs Allanson of Studley Royal on what had been two properties, one, an inn, used by the corporation for meetings. Wyatt's design included Assembly Rooms and a Committee Room. In his diary, Benjamin Newton, Rector of Wath 1816–18, mentions attending the Ripon Assembly, which had opened in 1801. Underground toilets at the front left of the picture served the public from 1899 to 2001.

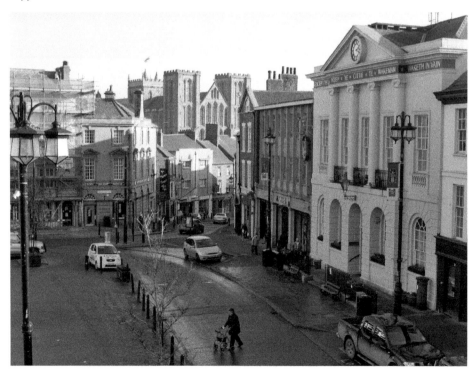

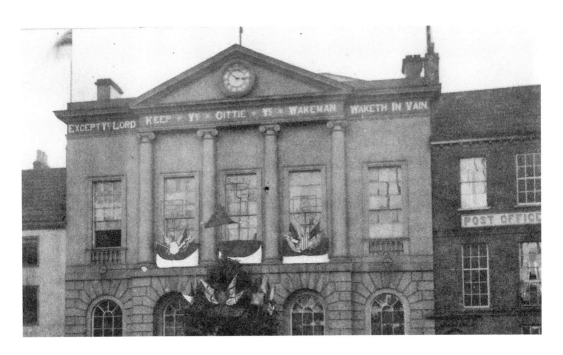

Ripon Town Hall

The town hall, decorated possibly for Victoria's Jubilee in 1897, when the Marquis of Ripon donated the building to the city council. The clock was a gift from the Yorkshire Agricultural Show Horticultural Society in 1859. The text, from Psalm 127, was added during 1886, Ripon's Millenary Festival. The post office was at 37 by 1890 until 1906 when Alves' florist took the shop (later Harkers) and the Lawrence Hotel the remainder. From 1966, it has been Halifax Building Society.

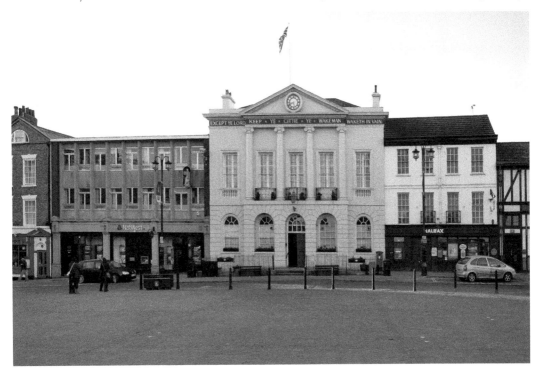

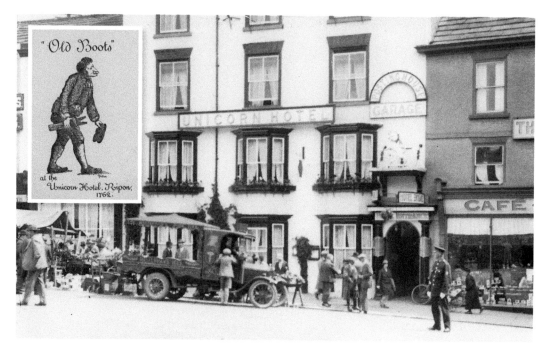

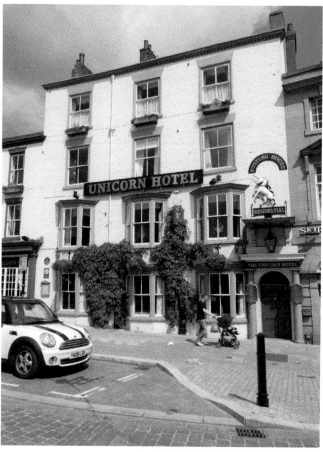

Unicorn Hotel (Wetherspoon's)
In the eighteenth century, Tom Crudd was the boot boy at the Unicorn Hotel, then Ripon's premier hostelry, where coaches for Leeds, London and Newcastle changed horses, as did scores of private carriages. Passengers would be entertained by the 'Old Boots', who, as well as offering boot-jack and slippers, would hold a coin, which he kept, between nose and chin, for their amusement and his enrichment.

Crown Hotel/Sainsbury's

In the eighteenth century, 5 Market Place was the White Hart Inn, by 1800 the New Inn, by 1811 the Crown and Anchor, by 1850 The Crown, and by 1900 the Crown Hotel. From 1908 to 1974, it was Croft & Blackburn's garage and showrooms, after which the premises were bought by Morrisons, which had a store there from 1977 to 2004 when it became Sainsbury's. The Crown had a carriage entrance with stabling for twenty horses, a coach house and parking for vehicles, although in 1901 sanitary arrangements were 'not good' and 'pigs are kept and allowed to run on the manure pit'. In 1907, its licence was revoked.

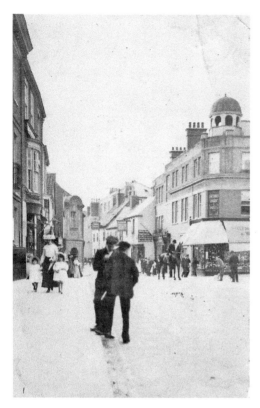

Market Place and Westgate
The building on the corner with its cupola, formerly Freeman, Hardy & Willis, now Stead & Simpson, and the bank at the High Skellgate junction are shown here in 1905. The cupola survived into the 1960s. The picture shows that Westgate's widening had begun, but the two pubs on the right – the Queen Alexandra and the Green Dragon – were still awaiting demolition. The scheme was never completed, and the road narrows again at Eccles Heddon, solicitor's.

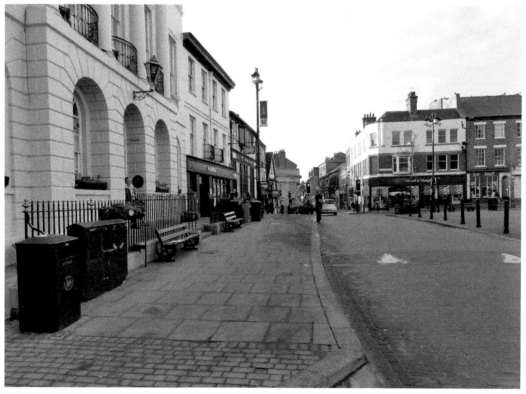

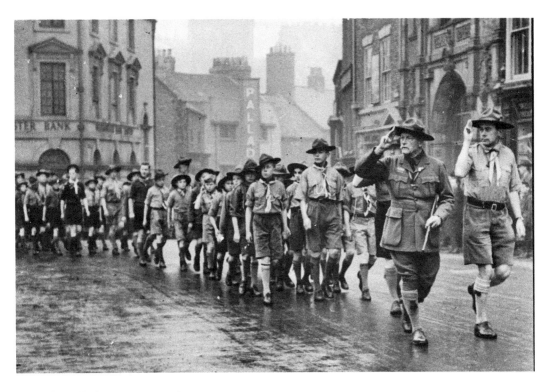

The Chief Scout on Parade
Lord Baden-Powell (*d.* 1941) leads a procession of local Scouts round Ripon Market Place, probably during the 1930s, after the widening of Kirkgate head.

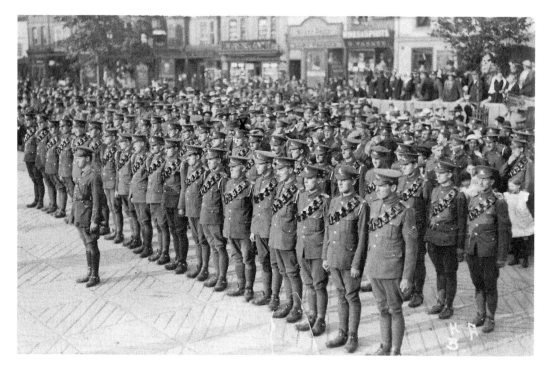

Troops on Parade

One of many occasions during the twentieth century for the military to parade through the city, culminating in the Royal Engineers being granted the Freedom of the City in 1949 and an annual march past and service in the cathedral on Remembrance Sunday. In the picture below, taken around 1998 or 1999, Mayor Barry Kay takes the salute as the soldiers march past.

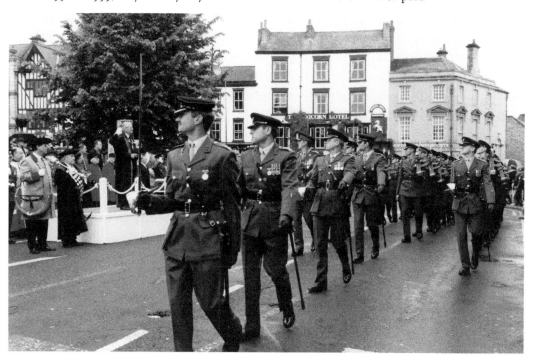

The Wakeman's House

This house was once thought to have been the home of Hugh Ripley, the last Ripon Wakeman. When the late-medieval house was threatened with demolition in 1917, the council bought it and added a wartime food kitchen. It was demolished in 2000 and made into public toilets. To its right, Thirlways was demolished around 1940. After restoration, the house became a local history museum, a café and the tourist information office. From 1990, it was occupied by Ripon Improvement Trust but has reverted to being a café.

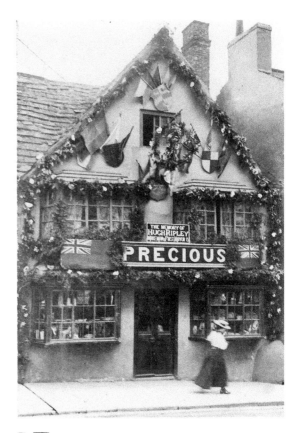

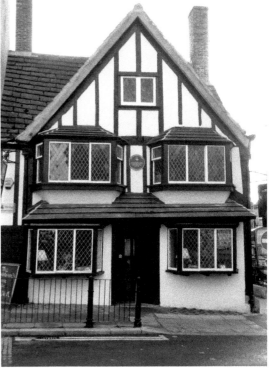

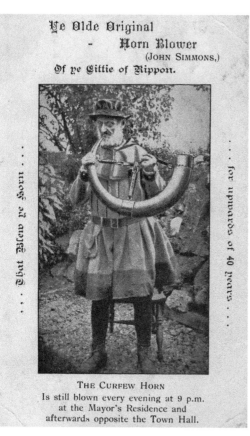

Ye Olde Original
- Horn Blower
(JOHN SIMMONS,)
Of ye Cittie of Rippon.

... That Blew ye Horn ...

... for upwards of 40 years ...

THE CURFEW HORN
Is still blown every evening at 9 p.m.
at the Mayor's Residence and
afterwards opposite the Town Hall.

The Hornblower
John Simmons, dressed for the 1886
Millenary Festival, died the following
year having served forty-one years as
hornblower. Unique to Ripon, nightly at
nine o'clock at the obelisk, the hornblower
'sets the watch'. For how long? Possibly
from the setting out of the new Market
Place in the thirteenth century. Notice that
the horn was blown first at the mayor's
residence, then opposite the town hall.
That reversed in 1913 so visitors could
catch the 9.29 train to Harrogate.

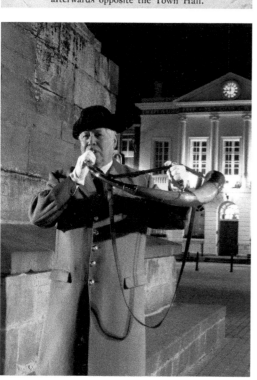

The Bellman

At 11 a.m. on Thursday mornings, the Bellman, whose office can be dated to before 1367, appears on the Market Square. The Cornmarket, which he is opening, actually started at noon. The Corporation had the right to levy a toll – Market Sweepings – on each sack of corn sold. His other duties included making announcements, starting the quarter sessions and administering whippings. He would be sent to cry 'Cautions!' if a breach of the by-laws was suspected.

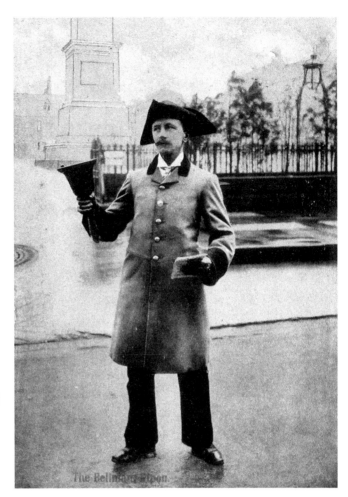

The Bellman at noon.

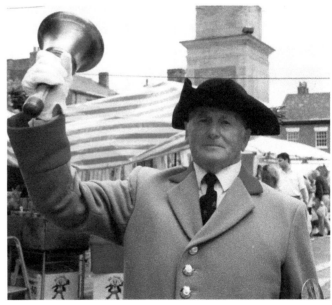

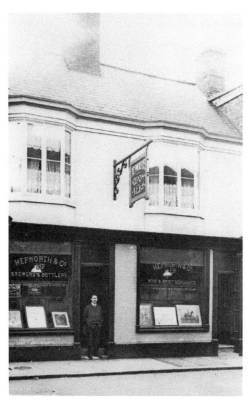

Hepworths Brewery

Thomas Hepworth from Skipton had taken over the Crown Brewery in Bondgate in the 1880s. By 1896, Hepworths had acquired malt kilns on North Street and within ten years had this office in Queen Street, together with a number of inns in the city, including the Unicorn. After the Second World War, Vaux Breweries took over Hepworths, but in 1957 ceased brewing in Ripon. The Queen Street premises became Rentons Estate Agents.

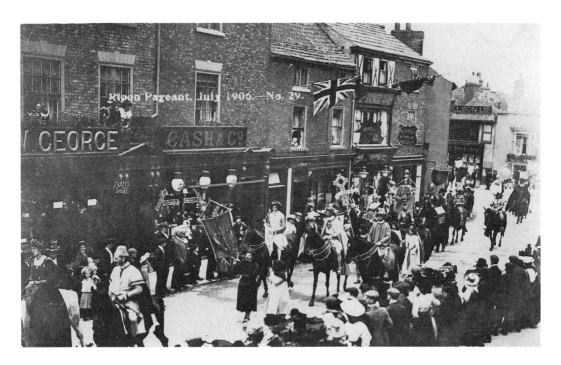

Queen Street

The 1886 Millenary Festival whetted Ripon's appetite for the big occasion. Ten years later, 1896, the pageant was 'Boadicea to Victoria'; 1904 brought the tercentenary of the 1604 James I charter; 1906 delivered a three-day Historic Festival with pageant, play and revels at Elmcrofts Park (now the Spa Hotel) and the new Spa Gardens. The war in 1916 and the depressed 1926 meant waiting until 1986 for the year-long 'Ripon 1100' festival.

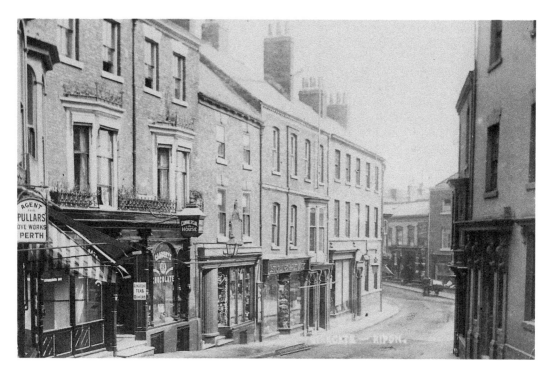

Kirkgate

The way to the church – thirteenth century and probably earlier. This traditional processional route links the town and the minster. This view is before 1916, as the Palladium Cinema has not arrived. Despite the construction of the bypass and other efforts to control traffic, this section of Kirkgate suffers from the heavy volume of traffic from the Market Place, but it otherwise differs little in character from Edwardian times.

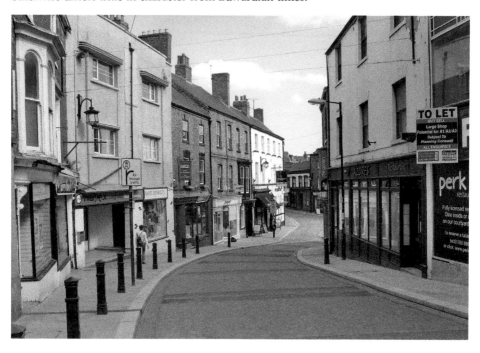

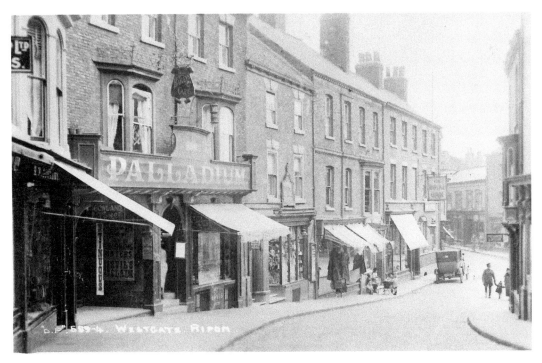

Kirkgate

Despite its 'Westgate' label, this is Kirkgate about 1926. At one time, this part of Kirkgate was known as Duck Hill and also as Cornhill. The Palladium Cinema opened in 1916, one of three helping to provide entertainment for the thousands of soldiers based at Ripon at that time. It was the last to close, in 1982, and became a night club.

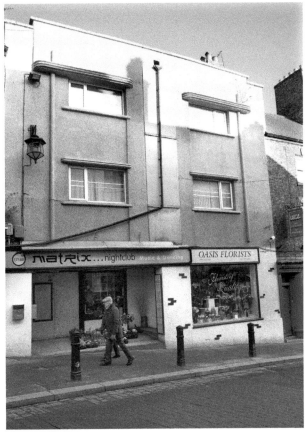

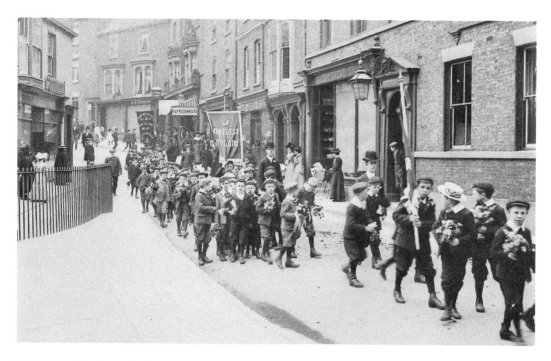

Kirkgate – Sunday School Procession

A 1904 newspaper report described how children 'brought flowers and other gifts for distribution amongst the sick, poor and children's hospitals. Sunday School banners were processed along Allhallowgate, Finkle Street, Queen Street, via the Market Place and Kirkgate to the Cathedral.' That year, 550 pupils and teachers took part, plus 15 from Jepson's Hospital and 30 from the girls' home.

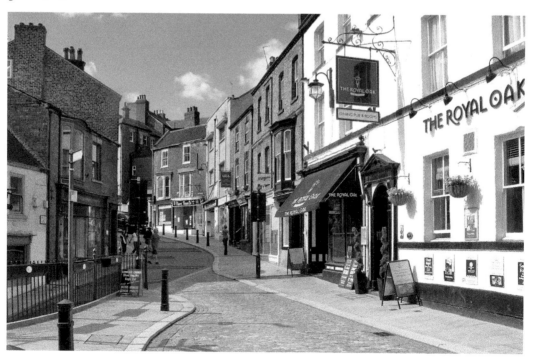

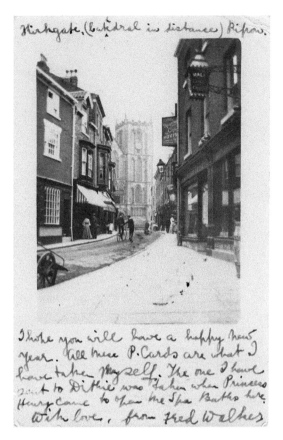

Kirkgate. (Cathedral in distance) Ripon.

I hope you will have a happy new year. All these P.Cards are what I have taken myself. The one I have sent to Dickie was taken when Princess Henry came to open the Spa Baths here. With love, from Fred Walkes

Kirkgate

Although Ripon was not a gated town, a gate at the end of Kirkgate is shown in an eighteenth-century drawing by Turner. That was to the churchyard and formed one of the sanctuary boundaries. Kirkgate is the one street left in Ripon retaining its medieval appearance. Lewis Carroll lodged twice with Mrs Barker at No. 32 and with Burnett, the Dean's Verger, at the last house on the right, since demolished. The card is postmarked December 1905 to California, USA.

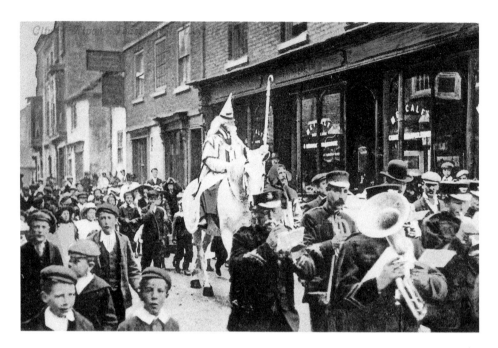

Kirkgate

From the early thirteenth century, in April, August and October, St Wilfrid's shrine would be carried down the street, the predecessor of today's Wilfrid processions. Destroyed at the Reformation, the procession was reintroduced with an effigy in the 1830s and a human figure from the mid-1840s. Other processions included the sanctuary men carrying their white staffs and the penitents, some on their way to be beaten or whipped at the church.

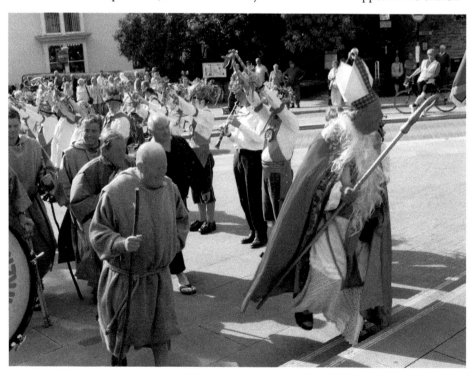

Ripon Cathedral West Front

With 110-foot towers, the West Front can be dated from indulgences of 1233 and 1258 to the period of the best period of Early English architecture. The three upper lancets lit the roof space, but have been blank since the nave roof was lowered. Timber spires were removed in 1664. The door has '1673' in nails. The pinnacles, added 1797, have been removed (c. 1940). Note the position of the clock – raised in 1906.

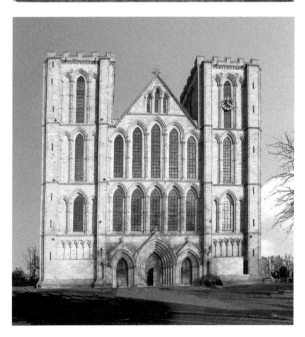

Ripon Cathedral, West Front.

Cathedral South Walk

The cathedral is approached from the South Walk by five steps. The very elaborate south doorway of the largely late-twelfth-century transept was once covered by a Renaissance porch. Of four orders, the uppermost projecting considerably, there are five shafts, two uncommonly sharing one abacus. The foliage on the capitals is almost Early English in style. It is said that those engaged in trade entered by this doorway, gentry entering through the west doors.

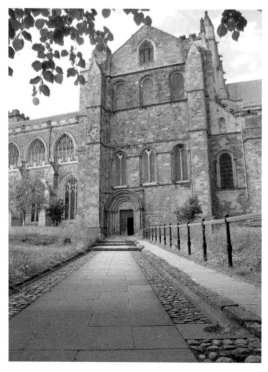

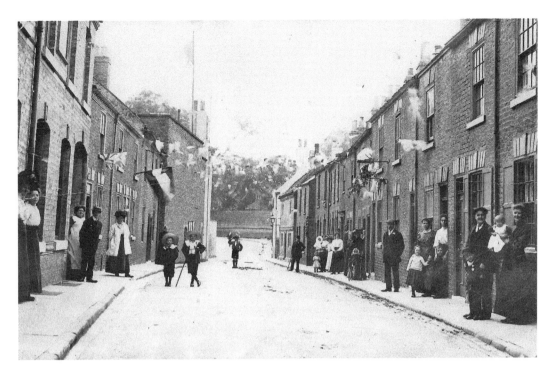

St Marygate

This street took its name from the chapel that earlier stood inside Huby's Wall (centre). As Stammergate, it was the last stop on the Rogation procession after Stonebridgegate, the route between the fords on the Skell and Ure and probably the oldest in Ripon. The House of Correction, centre left, operated from 1684 until 1816 until the prison was added. After 1880, it became the police station until the 1950s, opening in 1984 as a museum.

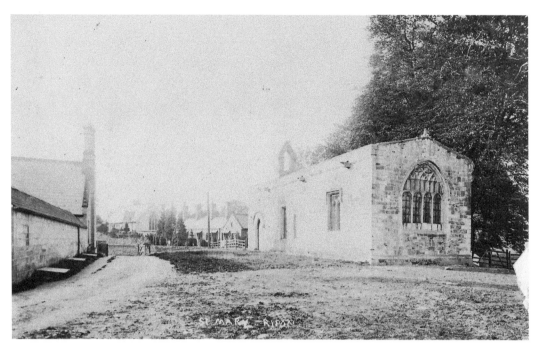

St Mary Magdalen's Hospital

The hospital was founded in the twelfth century for lepers and blind priests. By the fourteenth century, there were neither lepers nor sisters. A new chapel was built in 1868, six almshouses in 1875 and six more in 1890. The old chapel was in great decay, but after several restorations reopened in the late 1980s.

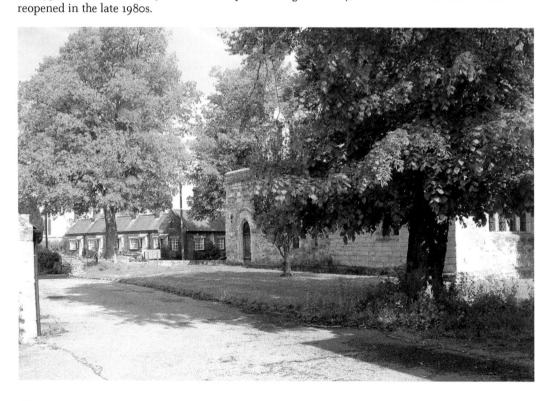

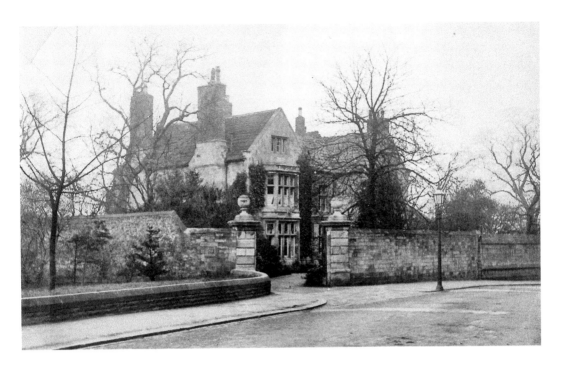

The Old Deanery

From the seventh century, St Wilfrid's monastery occupied the area to the north of the cathedral. In the fifteenth century, the Bedern College of Vicars-Choral stood here, replacing an earlier bedern on Bedern Bank. Following the granting of a new charter to the minster in 1604, this fine limestone building was erected for the canon-in-residence. In practice, it was occupied by the Dean. The seventh-century Ripon Jewel was discovered in the grounds in 1977.

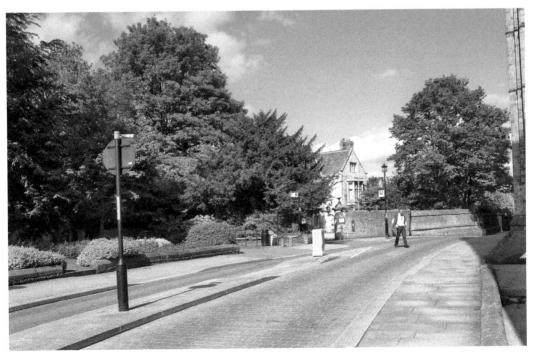

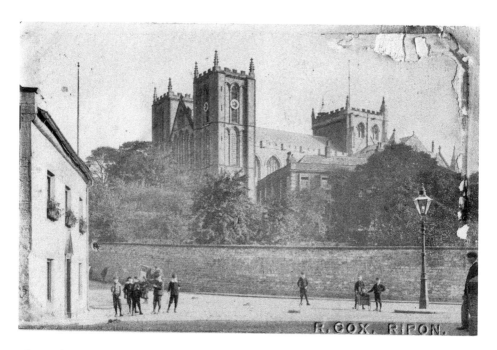

The Cathedral from Bedern Bank

Originally 'le Walkmilnebank', from the walk or fulling mill at the bottom, the Archbishop laid down in 1303 that the vicars should have permanent, paid appointments and live communally in a Bedern (or prayer house), so the street name changed, although in just over a hundred years the Bedern had moved. At the bottom left of the picture is the Kings Arms, one of Ripon's earliest inns. It was demolished by 1959 for road improvements.

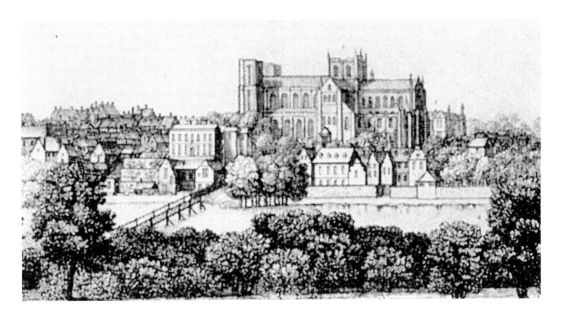

Bondgate Green Bridge

From 1810, Bondgate Green Bridge, still occasionally referred to as New Bridge, has carried the eastbound traffic out of Ripon along the Boroughbridge Road, replacing a narrow footbridge known as Chain Bridge or Archer Bridge, which stood a few yards downstream. The name Archer is thought to have come from the men practising archery on Bondgate Green. Bedern Bank originally led to this footbridge and High Saint Agnesgate started at the old hospital chapel.

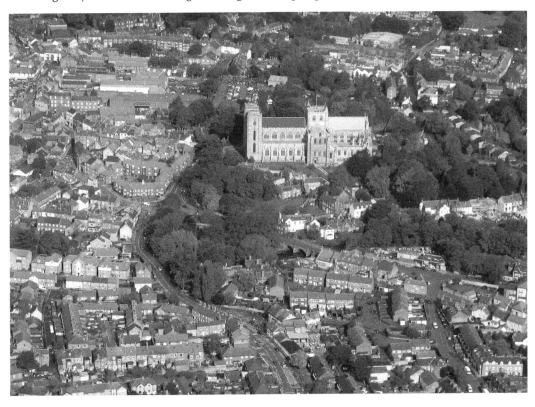

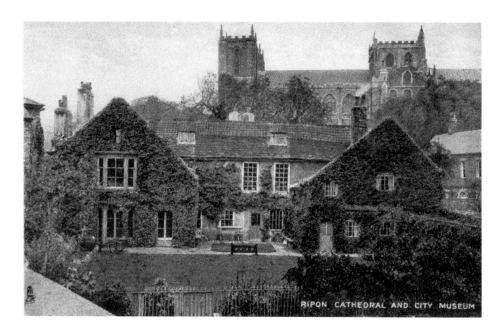

RIPON CATHEDRAL AND CITY MUSEUM

Thorpe Prebend

By the fourteenth century to the Reformation, Thorpe Prebend House was the residence of the prebendary of Thorpe, a canon of Ripon Minster. In April 1617, James I visited. In the nineteenth century, the house was converted into five cottages. Restored in 1913–14, it became the city museum until 1957, closing and badly deteriorating. After restoration in around 2002, it served for a few years as Ripon Cathedral Heritage Centre and is now used as part of the cathedral's education programme.

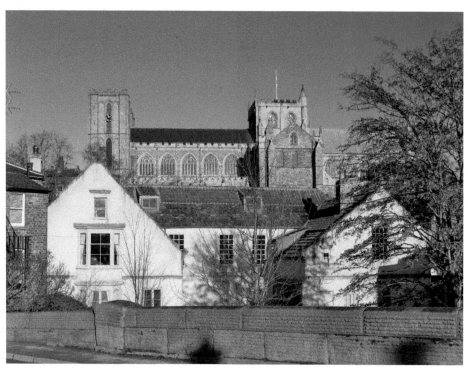

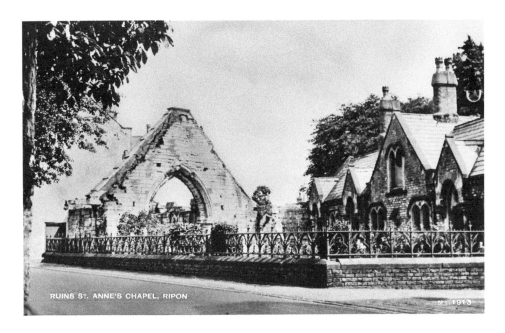

RUINS ST. ANNE'S CHAPEL, RIPON

St Anne's

By the old Archer Bridge, the smallest of the hospital chapels offered 'hospitality' in two dormitories, each with four beds plus two common beds and a resident chaplain. Annusgate is mentioned in 1228; Agnesgate in 1462. The earliest documentary evidence for St Anne's is in 1438, but parts of the building are considered to date from earlier. The 'nave' was demolished in 1869 when the almshouses were built. Restoration took place in the 1970s, and during the 1980s the accommodation was upgraded.

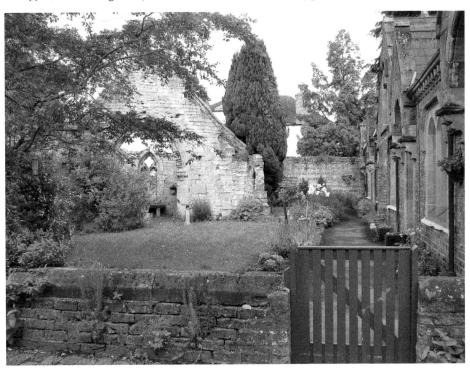

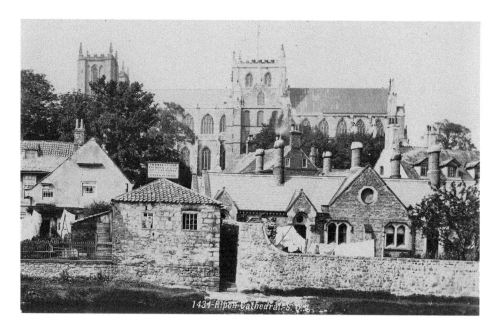

Band Room

This view shows the bandroom, tucked between Thorpe Prebend House and St Anne's, as a single-storey structure. About 1890, with Thorpe Prebend House, James Wright, plumber, bought it as a workshop and added the upper storey. Scratched into an upper window is 'Thomas Wright, plumber, 1889'. In 1919, the council leased to the city band 'the first floor of the warehouse adjoining the City Museum as a rehearsal room at a nominal rent of £2 per annum'.

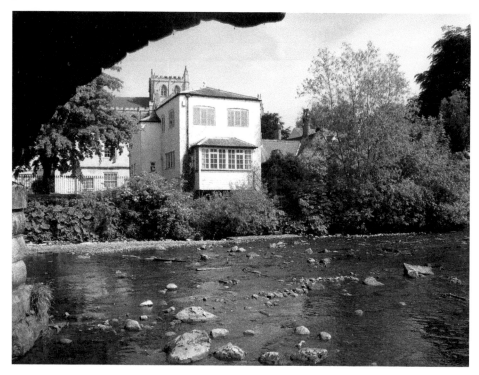

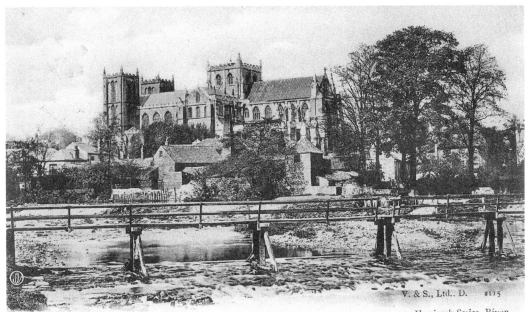

Ripon Cathedral from River

V. & S., Ltd., D. 2115

Harrison's Series, Ripon

Alma Bridge

After the battle of the Alma in the Crimean War, Alma footbridge was built in timber in 1862, 'entirely through the efforts' of Thomas Stubbs of Alma House. The weir fed Low Mill until 1939. To alleviate York flooding, in 1984–85 a new weir was constructed with a central salmon ladder. In 2010, flood scheme improvements began. The old tannery, in the centre of the picture, became Trees builders' yard, but was demolished for housing in 2009–10.

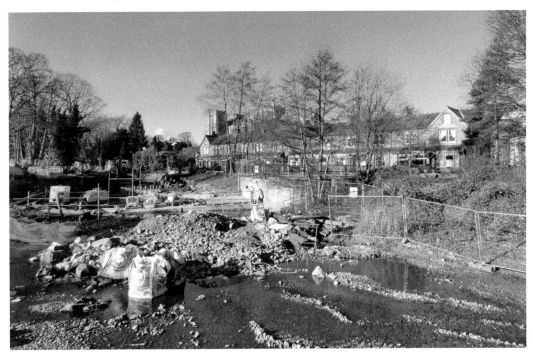

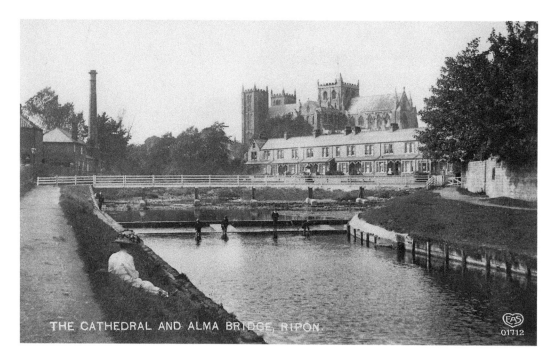

THE CATHEDRAL AND ALMA BRIDGE, RIPON.

01712

Alma Bridge

In 2001, the 1960s concrete Alma footbridge was rebuilt in timber. The view of the cathedral with Alma footbridge in the foreground became one of the classic views of Ripon in Edwardian times, as surviving postcards show. A weir appears here around 1800, feeding the leat to Low Mill. Skellfield Terrace was built in phases in the early years of the twentieth century.

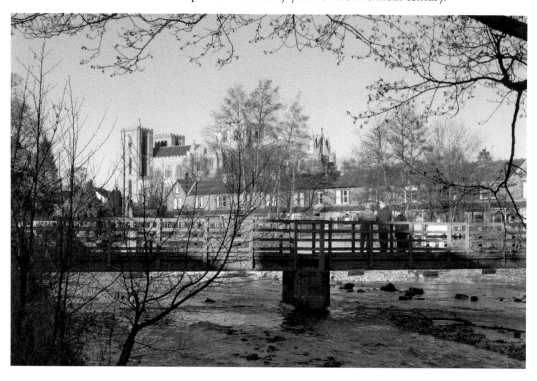

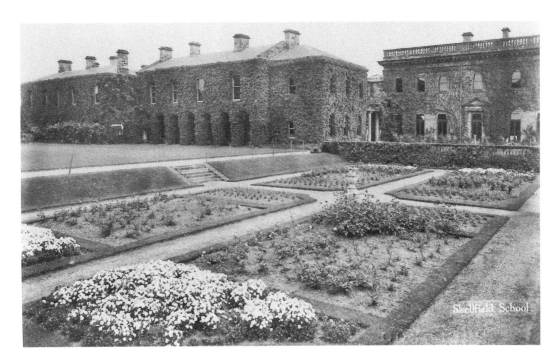

Alma House

Thomas Stubbs, Governor of the House of Correction and an enthusiastic collector of Crimean War memorabilia, lived here in his retirement. By 1880, Skellfield School occupied the building until 1927 with the author Naomi Jacob (1884–1964) as a day pupil. In 1927, the school transferred to Baldersby Park, closing in the 1950s. Sheltered accommodation was built in the grounds and local government offices occupied the house. Part is now the headquarters of the local federation of Women's Institutes.

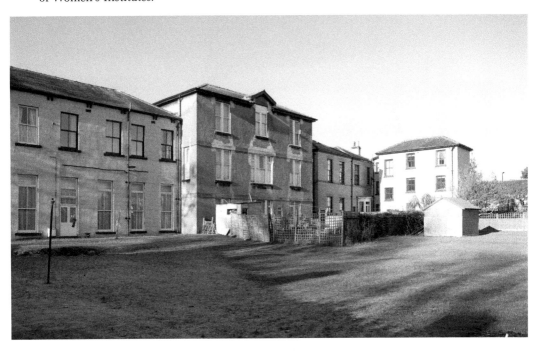

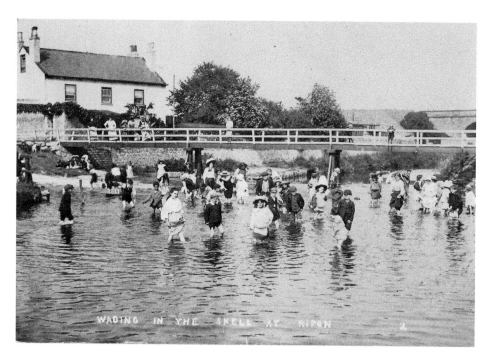

WADING IN THE SKELL AT RIPON

Woodbridge

Only a short distance below Alma Bridge, stands Woodbridge or Low Mill Bridge, another relatively modern footbridge, next to a ford still much used by local traffic and probably of great antiquity, linking with Allhallowgate and giving access to the traditional site of the Celtic monastery. The Domesday Book of 1086 records one mill at Ripon, which was probably East or Low Mill, mentioned in 1221, its successor standing nearby until 1938.

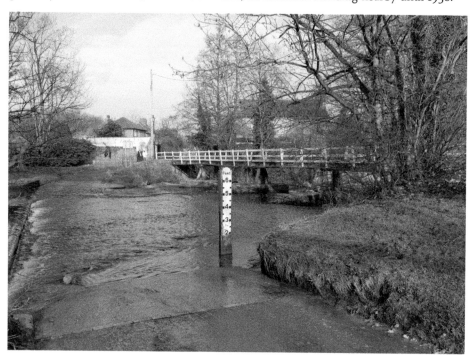

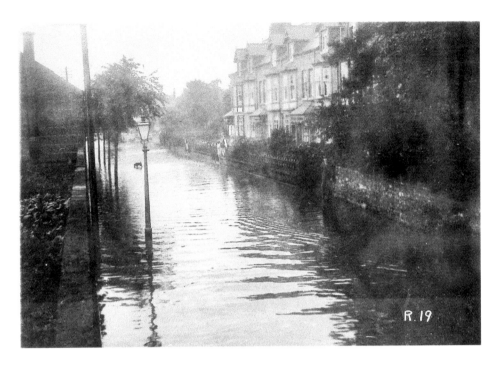

Firs Avenue

This picture probably relates to August 1927 when extremely high floodwater in the Skell swept away the Rustic Bridge and caused flooding in Firs Avenue. Williamson's fixed tablets on the Skell wall of their office marking the flood level of 8 August. The Ure and Skell were in flood in early July, and it was still raining in September. The bishop described the effect on agriculture as a national tragedy with crops standing in the fields ungathered.

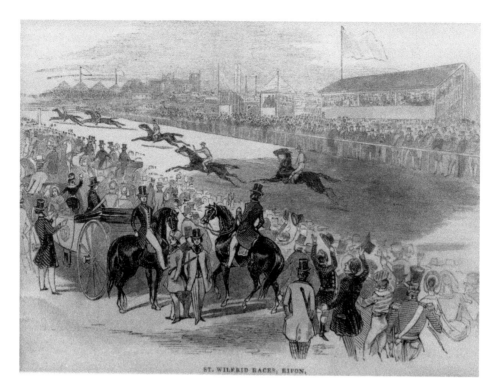

ST. WILFRID RACES, RIPON.

Racing

In 1717, racing started on High Common, initially just one meeting a year, including probably the earliest ladies' horse race in the country. It stopped in 1826, but restarted 'when a race course was formed and a stand erected on the north side of the river Yore'. Races were held here from 1837 until 1865, when a new course was laid out off Whitcliffe Lane, but that proved dangerous, and in 1900 racing moved to Boroughbridge Road.

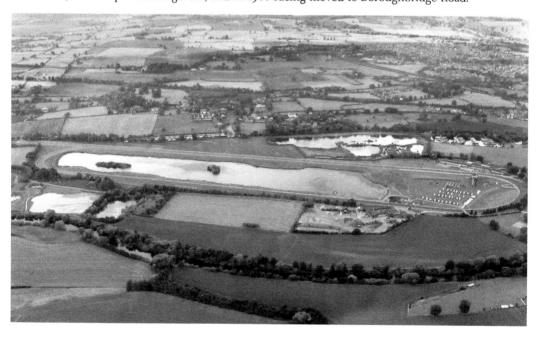

Ripon Canal

Built between 1767 and 1773, linking Ripon to the navigable stretches of the Ure, the canal took bricks, lead, butter, cheese, corn and agricultural produce and returned with coal. In debt by 1820, it was eventually bought by the Leeds & Thirsk Railway Company. In 1947, it was declared a 'remainder waterway' and the locks blown in, to be restored between 1982–97 through the Ripon Canal Society. Rebuilding round the canal basin began in 1999.

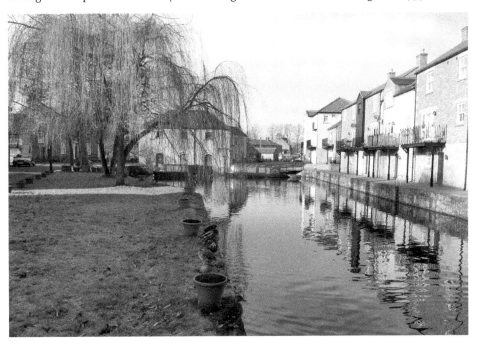

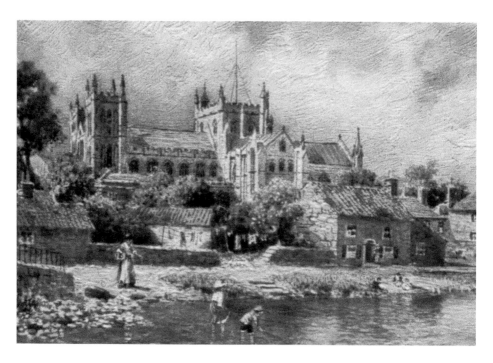

Mill Field

Bedern Bank was originally Le Walke Milne Bank because at its foot stood the fulling (walk) mill. By 1643, it was New Mill, a corn mill. Rebuilt later, it operated under a co-operative as Union Mill. Having lost its water supply in 1892, it was demolished in 1915 and the site was given to the city by the church as a children's play park.

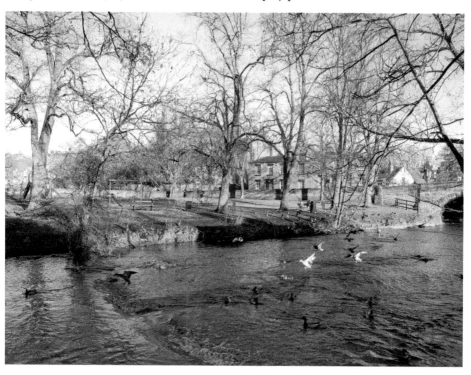

Ripon Cathedral from York Yard

This view would now have to be described as from Bedern Court. Possibly as early as the twelfth century, the mill race continued past Duck Hill Mill along Millgate (Skellgarths), making the road so narrow that by the 1830s the mill race here was the earliest to be covered over. In 1959, the site was cleared to be used to store fairground equipment, when it became part of Doubtfire's Yard. It was rebuilt around 1990.

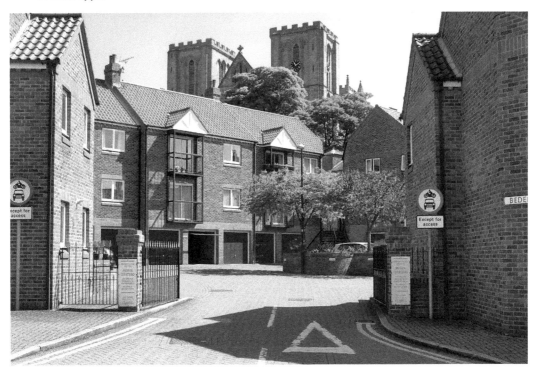

RIPON - THE CATHEDRAL FROM YORK YARD.

Duck Hill Mill

The bridge was essential, as the millpond practically filled Water Skellgate, the ducks giving the hill its name. Probably the second earliest of Ripon's corn mills, in the eighteenth century, when owned by Ald. Askwith of the Royal Oak, it pumped water up to the Market Place. After the collapse of High Cleugh dam in 1892, a steam engine drove the wheel, producing animal feeds until 1957 when the mill was put up for auction but withdrawn. In 1988, it was converted into dwellings.

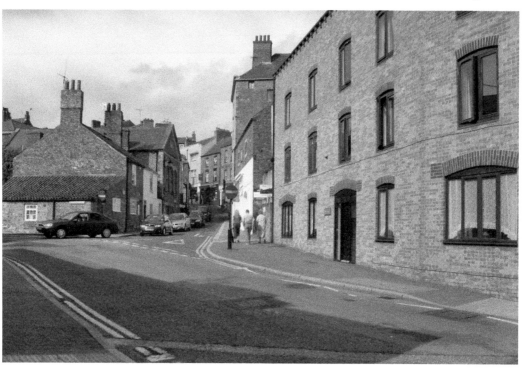

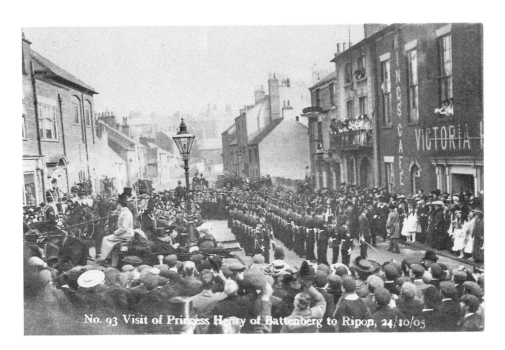

No. 93 Visit of Princess Henry of Battenberg to Ripon, 24/10/05

High Skellgate

High Skellgate appears as Over Skelgate in 1467, which, with Water Skellgate and Skellgarths, indicates the route of the Skell through the town. The mill race, extremely long for so early a construction, ran from a dam at High Cleugh and crossed Borrage Green Common. Remains can be found in the gardens of Mallorie Park Drive. Nine feet wide and twelve feet deep, it flowed down Somerset Row, Water Skellgate and Skellgarths, returning to the river near Bondgate Green Bridge.

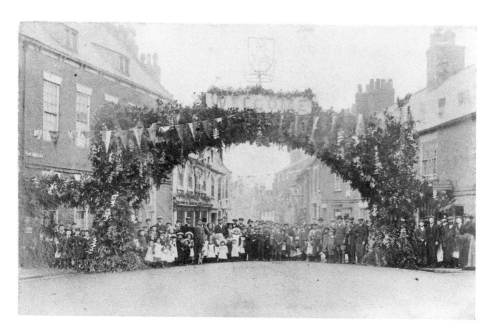

Low Skellgate

After the 1886 Millenary Festival, further festivals followed in 1896 and 1906. Welcome Arches were constructed at entrances to the city – this one is probably from the 1906 celebrations. Low Skellgate leads to Borrage Green and is first mentioned in the thirteenth century. Because of its narrowness, even since the construction of the A61 bypass, the street has suffered from heavy traffic, and businesses have found it hard to survive. The Turk's Head pub closed recently.

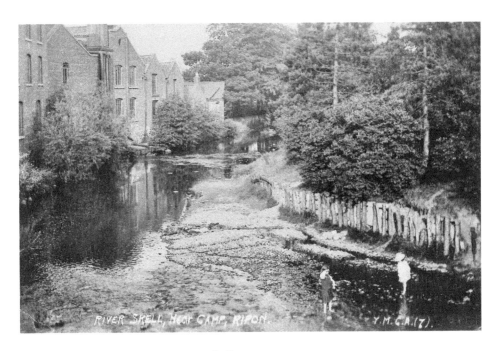

Williamson Paint Works and River Skell

Daniel Williamson befriended a Huguenot refugee who had found his way to Ripon. In return, Williamson was to learn the secrets of varnish making, in 1775 establishing a new industry in Ripon, eventually creating the first 'city of varnish' in the country. The office block close to Borrage Bridge dates from 1925; the works was further downstream. Williamsons moved to Stonebridgegate in 1985.

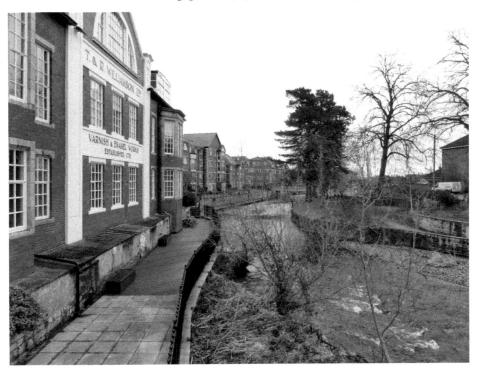

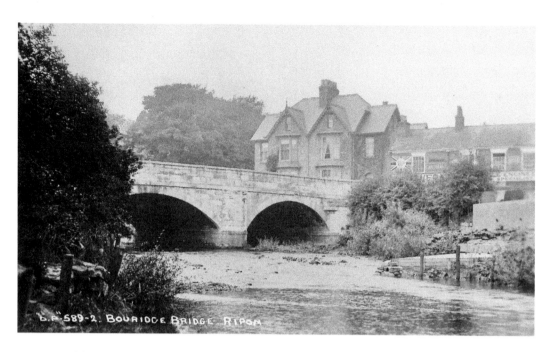

'b.P. 589-2. BORRIDGE BRIDGE RIPON'

Borrage Bridge

In the 1530s, this was a stone bridge, probably the one identified in fourteenth-century wills, e.g. Esgatebrigg, usually gifting funds for its repair. Being the first bridge over the river after it entered the town, the name possibly derived from 'Skell'. 'Borrage' has nothing to do with the plant, but refers to the burgesses who used the bridge to access their grazing rights on the common land of Borrage (burgage) Green. It was rebuilt in 1765 and widened in 1885.

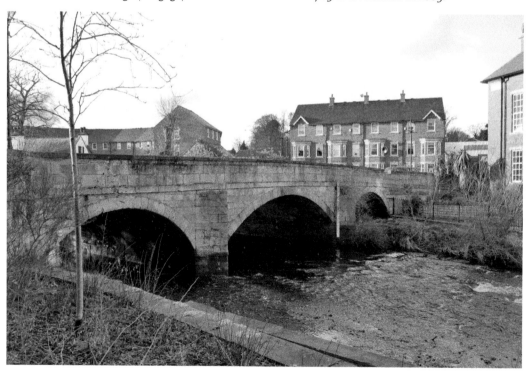

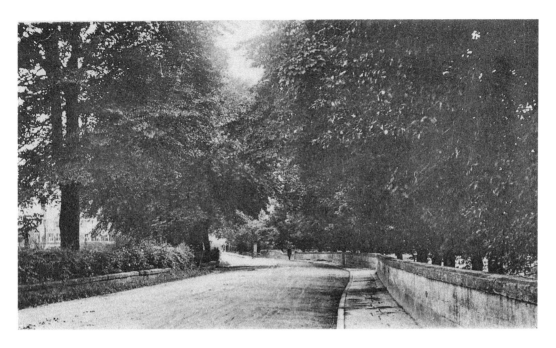

Harrogate Road

The main route south from Ripon was Bondgate, and there was little development along Harrogate Road until the nineteenth century. After 1918, the former Army Camp and eventually both sides of the road were developed. The wide road challenged motorists. In 1905, seven were convicted for exceeding the 20-mph limit. Several went back to see what they could clock on the return. The park, to the right, was presented in 1930 in memory of Tom Williamson.

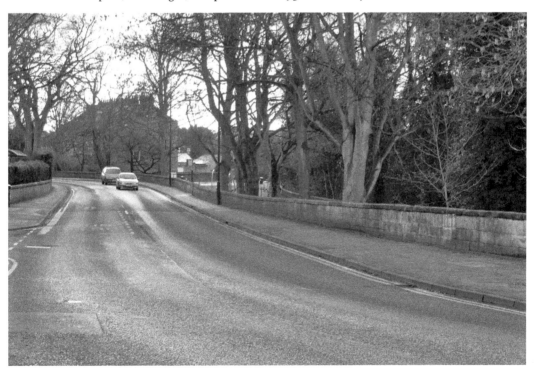

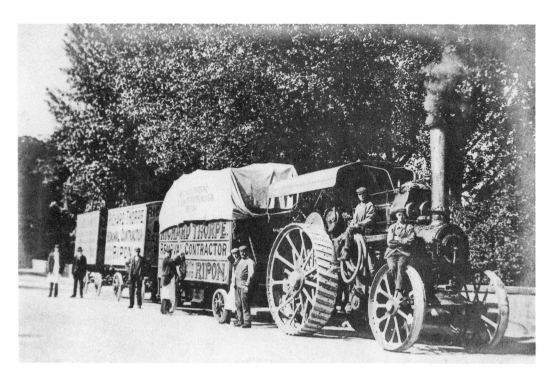

Thorpe's Removals on Harrogate Road

Son of John, a carter of North Road, Richard Thorpe's removal and storage business was established in North Road in 1897 and was much involved in the building of the South Camp along Harrogate Road in the First World War. He was a founder member of the British Association of International furniture removers and Mayor of Ripon from 1932–34. He died in 1940. See page 96 for Thorpe's premises at North Bridge.

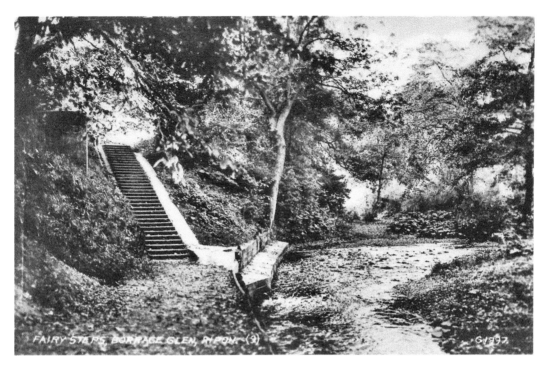

Fairy Steps

Further upstream, 'man-size' steps appear on early postcards although the Fairy Steps are claimed to have been built during the First World War. It is most likely that is when the wide side slopes were added to take the wheels of gun carts, with the shallow steps to assist the donkeys as they hauled the carts up the bank.

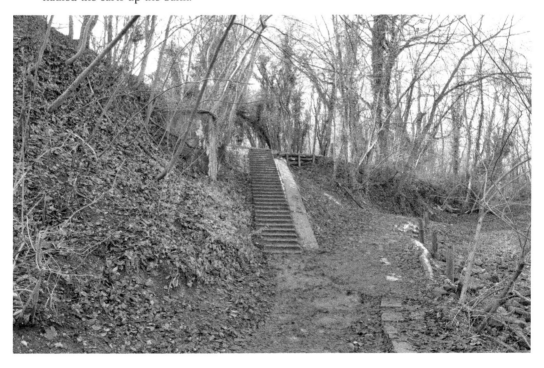

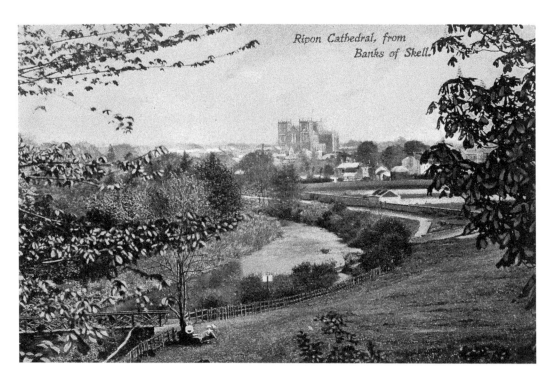

Ripon Cathedral, from Banks of Skell.

Rustic Bridge

In September 1898, a new wooden bridge of intertwined branches, also known as Willows Bridge, was built over the confluence of the Laver and the Skell. It was repaired in 1903, after Alderman Wells's child fell through. During the First World War, soldiers trekked across, but it was heavily damaged by flood in August 1927. In later years, it appeared in metal until the early 1980s.

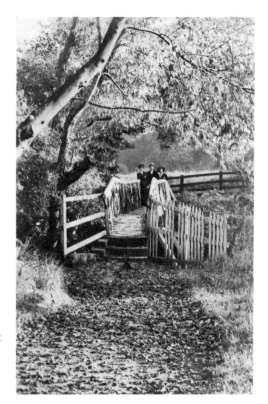

Rustic Bridge

The Rustic Bridge crosses the Skell near its confluence with the Laver. It offered a shortcut for a riverside stroll, for workers at Bishopton Mill, soldiers from the south camp or schoolchildren. It suffered from floods, insensitive repairs and vandalism over its first century of life. In 1984, together with other riverside improvements, the superstructure was rebuilt in timber under a government-supported work scheme.

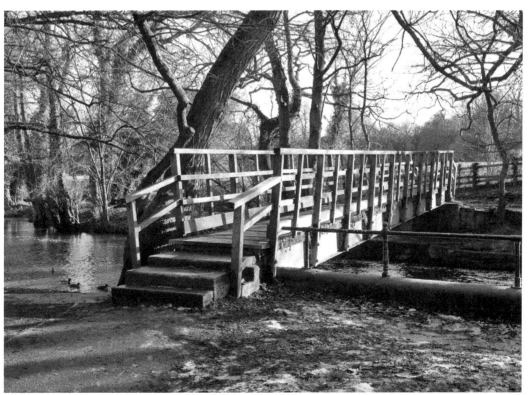

High Cleugh

The weir had already been washed away three times in the century when, in 1892, it collapsed, never to be replaced, closing down several corn mills along its millstream. In 1919, a scheme was drawn up to construct a miniature lake at High Cleugh but the city council declined to pay the £20 for materials. Stakes from the dam were still visible in 1948 when Riponians were getting used to the new concrete embankments and breakwaters.

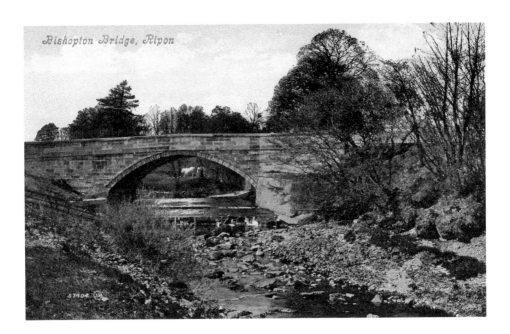

Bishopton Bridge

The road westwards from Ripon to Fountains Abbey and Pateley Bridge crosses the River Laver via Bishopton Bridge, recorded by the fourteenth century. In 1501, collections at the chapel to St Mary, on the bridge, amounted to 5s 3d. In the 1520s, the chapel was occupied by a hermit. Three years later, he was described as a malefactor, arrested and taken to York Assizes. The road was turnpiked about 1760, and the upstream section of the bridge may date from then.

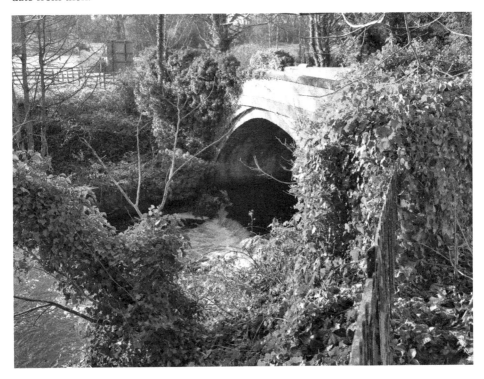

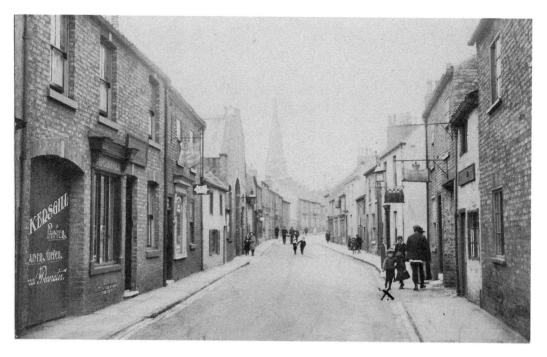

Blossomgate

From a 1228 court case, we know that nearly all Blossomgate had messuages and tenements, the rents mostly allocated to the prebendary of Monkton, treasurer of the minster. Between Blossomgate and the Market Place was a field known as Treasurer's Garth. In 1858, because of dirt and disturbance, for some three years cattle and sheep fairs were moved there from the Market Place. It was sold for building at the end of that century.

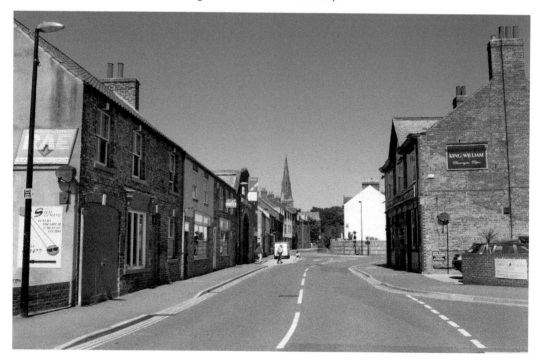

Holy Trinity Church

The tall, broach spire of Holy Trinity Church, on the western side of the town, is one of Ripon's landmarks. In Early English style, it was built between 1826 and 1928 with galleries, since removed. Holy Trinity was adopted by the tradesmen as their church, particularly after the minster became the cathedral in 1836. In 1984–85, the crypt was cleared of burials and refurbished to provide social and meetings areas, and in 2001 further work extended this facility.

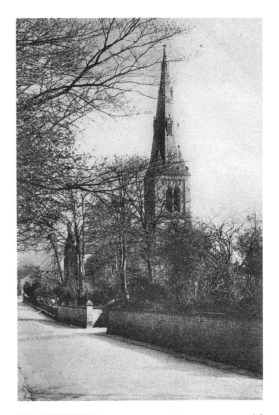

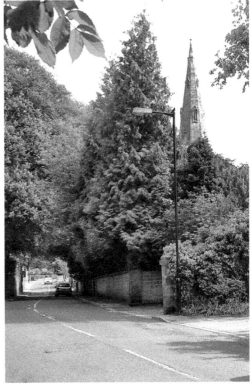

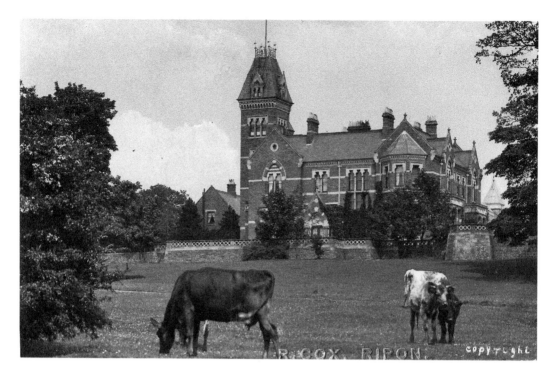

Ripon Grammar School

A grammar school was attached to the minster in the medieval period, losing its revenues and closing in the aftermath of the Reformation, but it was re-endowed in 1555. There were boarders by 1729, but during the nineteenth century, the school lacked facilities and was struggling against competition from the National Schools. In a deal of 1874, it transferred to Bishopton Close School premises, remaining a boys' school until 1962 when it merged with the Girls' High School.

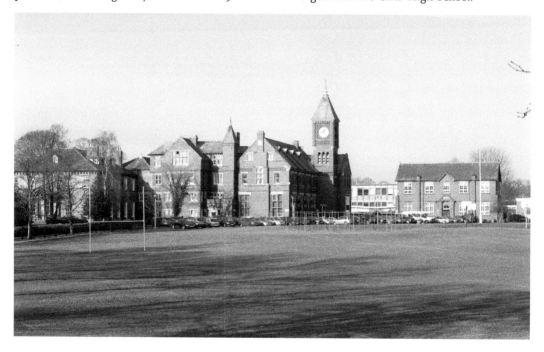

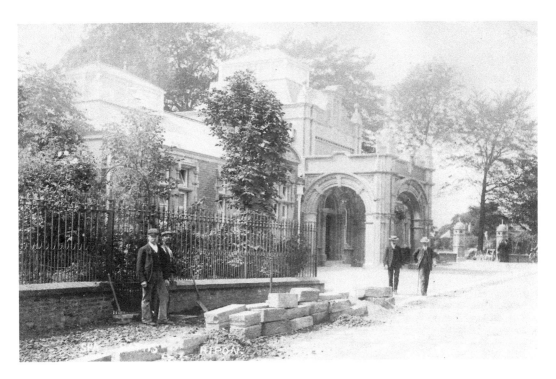

Spa Baths, Ripon

This delightful card is postmarked 3 August 1906. In 1905, the new spa baths had opened, the ornate interior of the Pump Room finished with tile, marble and stained glass. The baths were open from 7 a.m. to 7 p.m. Admission and a glass of sulphur water cost one penny each. As elsewhere, the spa declined in the interwar years, and in 1936, after many years of waiting, a public swimming bath was incorporated into the building.

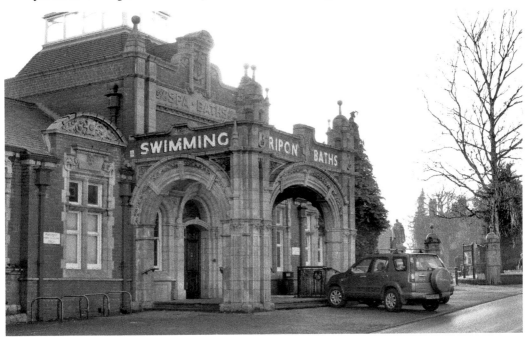

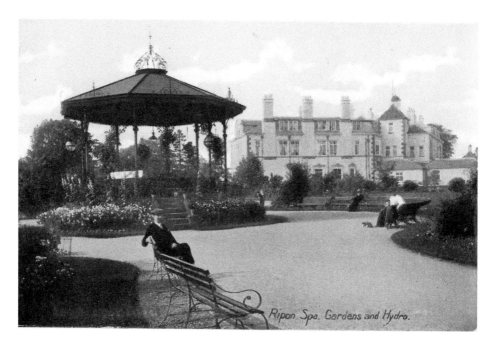

Ripon Spa. Gardens and Hydro.

Spa Gardens

The link between taking the waters and taking fresh air and exercise was strongly emphasised. In 1900, the Marquis of Ripon sold the former drill field for a pump room and spa. The gardens were laid out in 1902. The bandstand followed a year later and, against much opposition, Sunday concerts were presented from 1905. The Spa Gardens, winner of the Green Flag award for several years, now contains a café, bowling green and a miniature golf course.

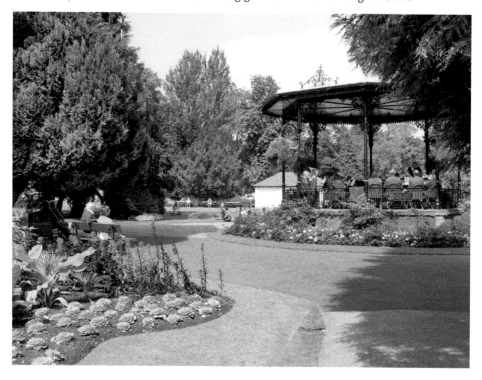

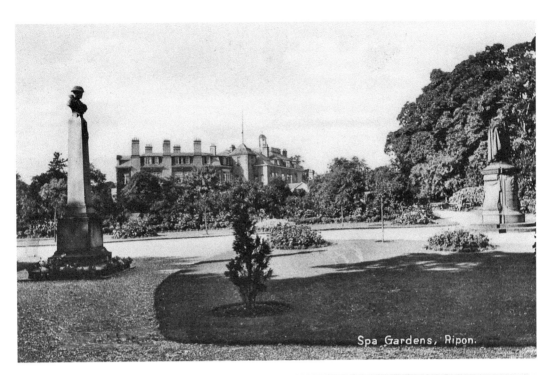

Spa Gardens, Ripon.

Spa Gardens: the Marquis of Ripon

Inside the Spa Gardens a statue of the
Marquis of Ripon (1827–1909) was unveiled
in May 1912. Born at 10 Downing Street, he
went on to a distinguished career with the
Liberal Party, holding many high offices
but still finding time to become Mayor of
Ripon (1895–96) and to take an interest in
local affairs, especially education. The war
memorial was added later.

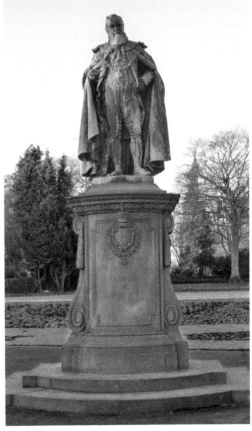

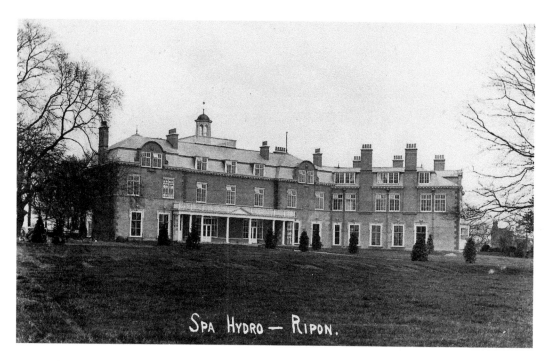

Spa Hydro/Hotel

The creation of the spa was an attempt to raise Ripon's depressed economy in the first decade of the twentieth century and to generate a demand for accommodation. To that end, the Spa Hydro (now Spa Hotel), was built in 1906 by Sir Christopher Furness of Grantley Hall on the old Elmscroft estate. It opened in 1909. The croquet lawns now host national competitions.

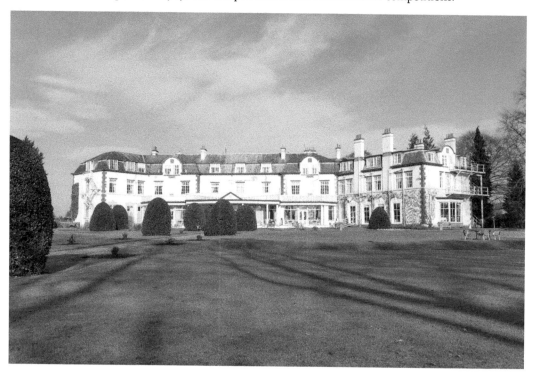

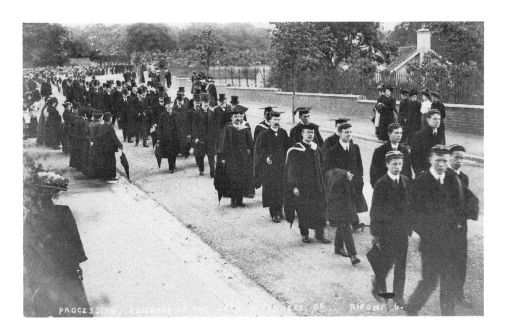

PROCESSION ... FUNERAL ... OF ... RIPON. 6.

Studley Road

George Frederick Samuel Robinson, 1st Marquis of Ripon, Grand Master of the Freemasons 1870–74, Viceroy of India 1880–84, was born at 10 Downing Street during his father's short premiership and died on 9 July 1909. Having converted to Roman Catholicism, the funeral service was at St Wilfrid's Catholic church, Ripon, followed by a funeral procession of enormous length to the burial place at St Mary's, Studley. A Requiem Mass was sung at Westminster Cathedral.

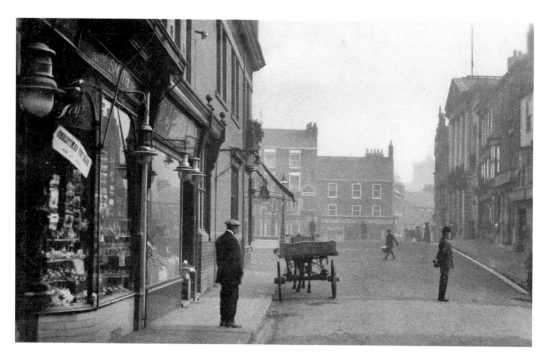

Westgate

From 1902–05, widening took place at the top of High Skellgate and, before coming to a sudden halt, along part of Westgate. The cart stands outside No. 1, James Eden's greengrocer's. The street led westwards via Blossomgate to Bishopton Bridge, until High Westgate (later Park Street) was developed in the late seventeenth century.

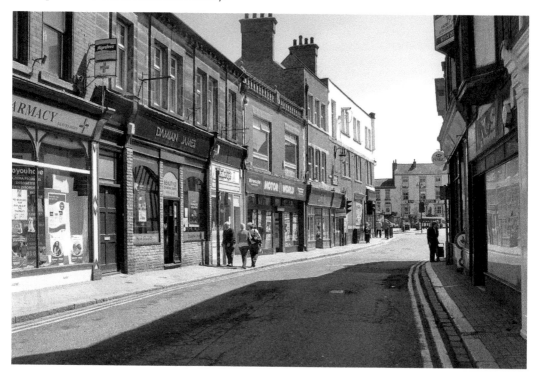

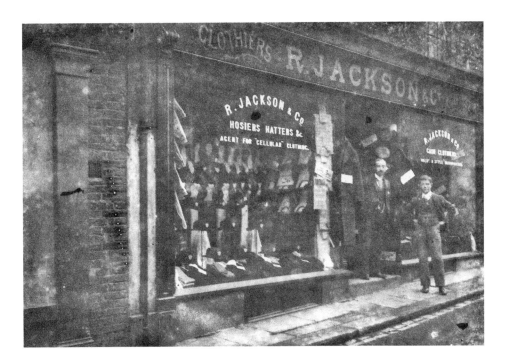

Westgate

Richard Jackson founded his drapers and millinery business on Westgate in 1884, eventually expanding into furnishings, carpets, rugs, linoleum, oil cloths, mats, etc., and occupying Nos 27 and 28. Number 30 was added in 1889 and was devoted to male clothing. The stock and workrooms were on the second floor where 'the work done ... by his numerous and skilful assistants will favourably compare with that of some of the most pretentious Metropolitan firms'. The business survived until the late twentieth century.

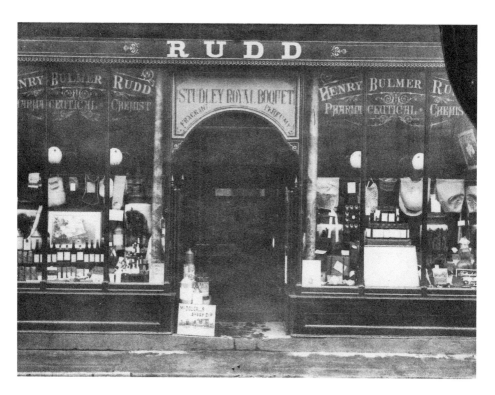

Westgate

As well as being a chemist, Henry Bulmer Rudd was a highly competent photographer whose images of Ripon streets, photographed in the rain, are of great interest.

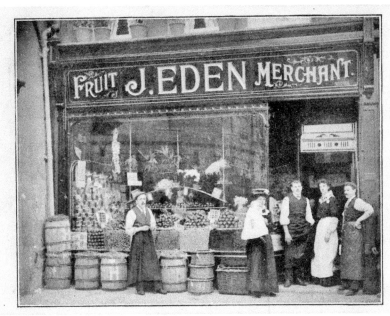

J. EDEN

High-Class
English and
Foreign
Fruiterer,
**WESTGATE
RIPON.**

Fruits of the
Choicest
Quality.
Noted for
Good
Potatoes.

Telephone No.
12 Y.

Westgate

The practice of photographing owners, staff and sometimes customers outside the shop became a popular advertising practice around the turn of the twentieth century, with the pictures often used to accompany entries in trade directories or on business cards, as here. James Eden's fruiterer business expanded into a wholesale and retail operation with warehouses along Princess Road.

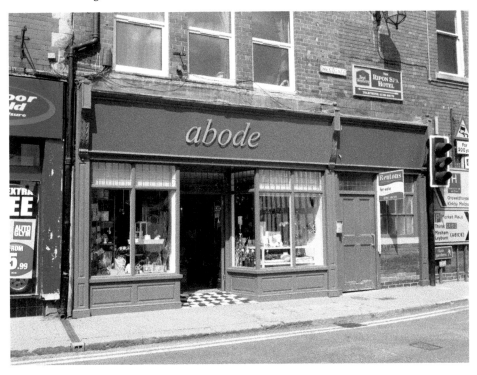

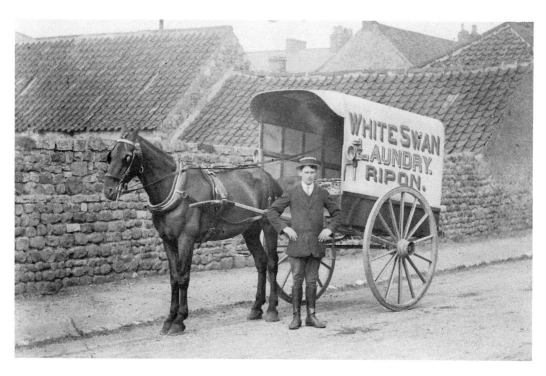

Westgate/Black Swan Yard

The picture above shows the White Swan Laundry collection and delivery cart, with laundryman Frank Grainger. For a long time, Mrs Hardisty was manageress. Mr Knowles, who also drove the laundry van, later became manager. The laundry was located in the Black Swan Yard, seen below.

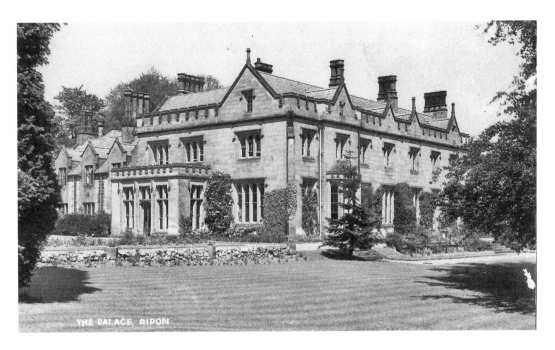

Bishop's Palace, Palace Road

Designed by William Railton, a London architect, the Bishop's Palace was built between 1838 and 1841, for the first Bishop of Ripon, the Right Reverend Charles Longley. In 1940, it was superseded by the more modest Bishop Mount on Hutton Bank, after which the old palace underwent conversion to a Dr Barnardo's school. It is now private housing. The picture below shows the Bishop of Ripon and Leeds, John Packer, and Dean Keith Jukes in the cathedral.

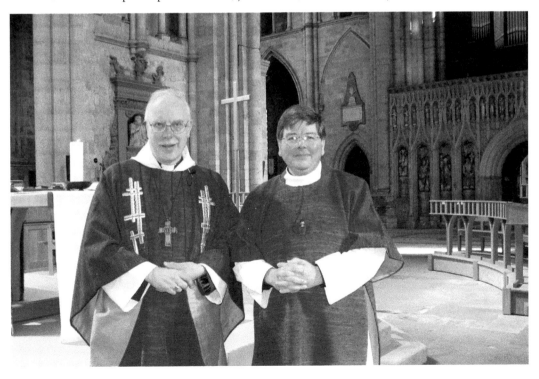

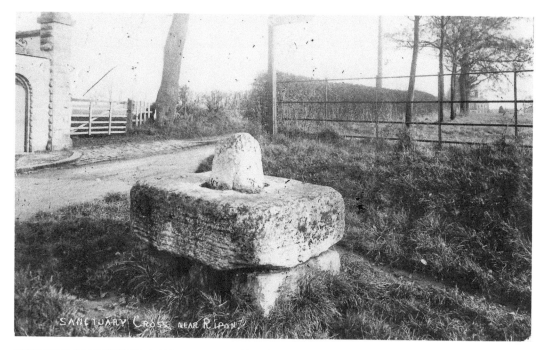

SANCTUARY CROSS. NEAR RIPON.

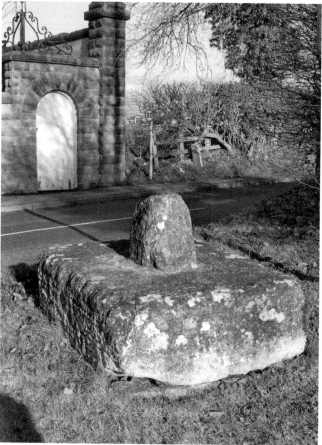

Sharow Cross

The stump of the sanctuary cross at Sharow is all that survives of the two rings of crosses that marked the bounds of the medieval chartered sanctuary associated with Ripon Minster. The crosses of the outer ring stood where the eight radial roads met the town boundary and the inner ring at points roughly half way to the minster. The remnants of the two crosses that survived into the nineteenth century, Sharow and Kangel, probably formed part of this inner ring.

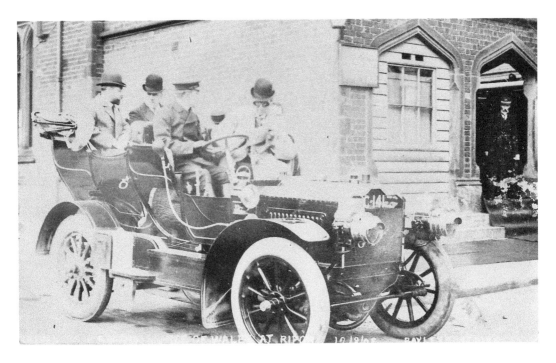

Princes of Wales

Two Princes of Wales, a century apart, visited Ripon on a number of occasions. Above, the prince who became King George V was a guest of the Marquis of Ripon, particularly during the shooting season. Below, Prince Charles, whose Institute of Architecture produced the report 'A Vision of Ripon' in 1994, visited Ripon on a number of occasions in the following years, below in 2002.

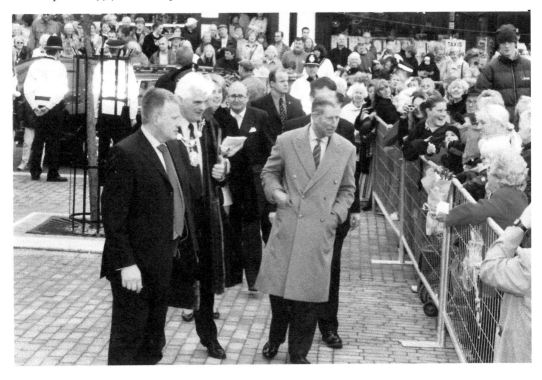

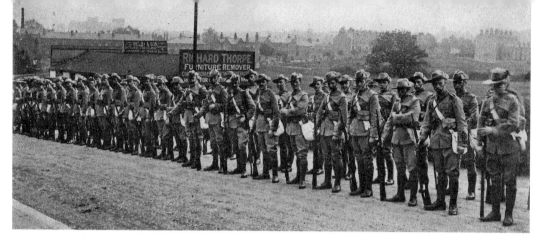

1st VB Northumberland fusiliers Ripon 1907 at station approach.

Acknowledgements

Many people have assisted us in gathering pictures and information for this book. Unfortunately, it is not possible to mention all by name, but our thanks are no less sincere.

In addition to those who have loaned us pictures, the authors would like to express particular thanks to Steve Daly, Ron Darwin, John Harrison, Barry Kay, Sainsbury's, Stead & Simpson, Thomas's Bakers, WHSmith.

Historic Pictures:
Revd Tony Shepherd: 6 (inset), 11, 14–17, 30, 34, 36, 42, 44–46, 59, 60, 62, 71, 83, 88, 95.
Alan Stride: 5, 7, 9, 32 (inset), 34 (inset), 41, 61, 84, 85, 94.
Barry Drury: 3, 18, 21, 22, 25, 33, 37, 38, 43, 47, 48, 50–52, 54, 66, 67, 69, 70, 74, 74, 80, 82, 87, 89, 90, 92.
Malcolm Hutchinson: 2, 8, 12, 13, 19, 27–29, 31, 32, 39, 40, 49, 53, 58, 63, 72, 75–77, 79, 82, 86, 91, 93.
Maurice Taylor: 6, 10, 20, 23, 26, 56, 57, 64.
John Heselton: 35; Ian Stalker: 65; John Wimpress: 78; Douglas Atkinson: 55.
George Fossick and Ripon City Council: 68.

Modern photographs:
Ian Stalker: 5–9, 13, 16–18, 21, 23–27, 29, 31–35, 40, 45, 48, 49, 51, 56, 60–63, 65, 66, 72–77, 79, 80, 82–87, 91, 94.
Maurice Taylor: 10–12, 14, 15, 19, 22, 28, 30, 36, 37, 39, 42–44, 46, 47, 50, 42–54, 57–59, 67–71, 78, 81, 88–90, 92, 93.
Peter Hills & David Thelwall: 55, 64; Ella Benigno: 95; Bill Robson: 41; © North of England Newspapers. Newsquest North East Ltd: 38.

Principal reference sources: *Ripon Millenary* (1892); *Ripon in Old Picture Postcards* (ed. M. H. Taylor, 1985); *A Ripon Record* (1986); *Ripon Market Place* (ed. Mike Younge); *Echoes from Ripon's Past* (ed. Mike Younge, 2004); *An Illustrated History of Ripon* (Maurice Taylor, 2005).